ELKMONT'S
UNCLE LEM OWNBY

Sage of the Smokies

F. CARROLL MCMAHAN

THE
History
PRESS

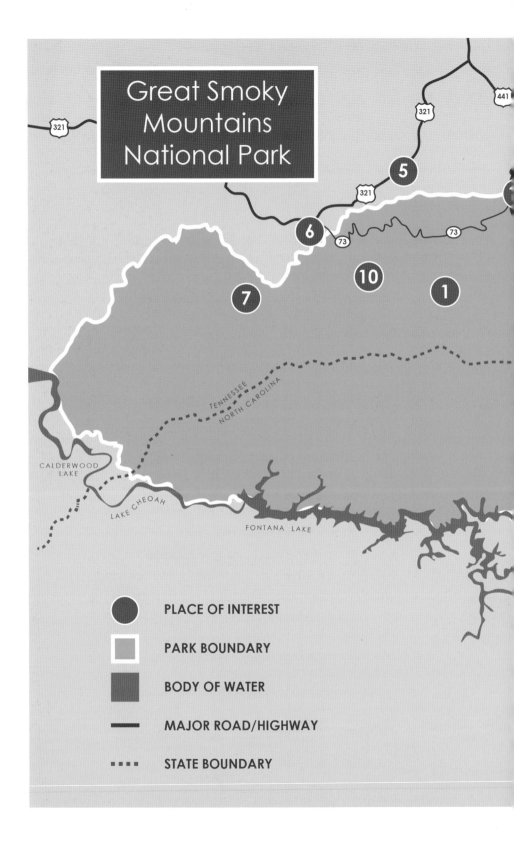

Great Smoky Mountains National Park

PLACE OF INTEREST

PARK BOUNDARY

BODY OF WATER

MAJOR ROAD/HIGHWAY

STATE BOUNDARY

321
321
441
321
321
5
6
73
73
10
7
1
TENNESSEE
NORTH CAROLINA
CALDERWOOD LAKE
LAKE CHEOAH
FONTANA LAKE

PLACES OF INTEREST IN THE LIFE OF LEM OWNBY

1. Elkmont: Lem Ownby home site.
2. Greenbrier Cove: Where John Ownby settled in 1833.
3. Dudley Creek: Where Jemima Ownby was born and raised.
4. Gatlinburg: Where Lem Ownby's parents grew up.
5. Wear's Valley: Where most of Lem's relatives relocated when park was established.
6. Townsend: Little River Lumber Company headquarters.
7. Cade's Cove
8. Clingman's Dome: Highest peak in the Smokies.
9. Shady Grove: Where Lem's maternal grandfather relocated.
10. Tremont
11. Sugarlands
12. Cosby

Published by The History Press
Charleston, SC 29403
www.historypress.net

First published 2013

Manufactured in the United States

ISBN 978.1.62619.119.8

Library of Congress Cataloging-in-Publication Data

McMahan, F. Carroll.
Elkmont's Uncle Lem Ownby : sage of the Smokies / F. Carroll McMahan.
pages cm
ISBN 978-1-62619-119-8 (pbk.)
1. Ownby, Lem, 1889-1984. 2. Elkmont (Tenn.)--Biography. 3. Great Smoky Mountains
National Park (N.C. and Tenn.)--Biography. 4. Great Smoky Mountains National Park
(N.C. and Tenn.)--Anecdotes. 5. Mountain life--Tennessee--Elkmont Region--Anecdotes. 6.
Mountain life--Great Smoky Mountains National Park (N.C. and Tenn.)--Anecdotes. I. Title.
F444.E45M35 2013
976.8'89--dc23
2013037056

Dedicated to the memory of my beloved Mimi.

*My son, eat thou honey, because it is good; and the honeycomb,
which is sweet to thy taste.*
—Proverbs 24:13 (KJV)

CONTENTS

ACKNOWLEDGEMENTS

I would like to thank the following people, without whom this publication would have remained a dream: Winfred Ownby, Lem Ownby's grand-nephew, who helped immeasurably in putting the pieces of the Ownby family tree together and invited me into his home, provided photographs and shared colorful reminisces about his great-uncle; the staff of the Rel and Wilma Maples History Center at the King Family Library, particularly Theresa Williams and Tim Fisher, who not only provided work space but also assisted in the research and the provision of images.

I'm extremely grateful to my brother-in-law Richard Atchley Jr. for his assistance in formatting the images. I also owe a great deal of gratitude to Elizabeth Ballard for allowing me the use of her invaluable collection of photographs.

Others I relied on for support include Annette Hartigan, archivist at the Great Smoky Mountains National Park; Kent Cave, supervisory ranger at the Great Smoky Mountains National Park; my colleagues, especially David Stanfield and Chelsie Watson, who provided unwavering assistance; and Dan Paulin for providing photographs and sharing his knowledge of the subject.

Words are not adequate to express the gratitude I owe Jo Harris, who graciously gave of her time and talents proofreading, making corrections and offering suggestions. She spent countless hours poring over the manuscript. I will always be indebted to her for the expert guidance and support she provided in order to bring this project to fruition.

Finally, to my wife, Michelle, thanks for keeping me focused, reminding me of deadlines and your understanding and steadfast support, as well as never once complaining about the time this project was taking from us.

INTRODUCTION

Growing up near the Great Smoky Mountains National Park, I often heard stories and read articles in newspapers and magazines about the famous Walker sisters of Little Greenbrier Cove, who chose to remain in their isolated cabin when the park was established. Accounts of such rugged mountaineers, who cleaved to the ways of the past when a more comfortable, modern lifestyle was within their grasps, always fascinated me. Louisa Walker, the last of the Walker sisters, died in 1964. As far as I knew at the time, there were no others residing within the boundaries of the national park on a life-lease agreement. Later, I discovered that was not the case.

I was in my twenties when I read an article in the Sunday edition of the *Knoxville News-Sentinel* about the last living life lessee in the Great Smoky Mountains National Park. The article, "Last Resident of the National Park," appeared in a column written by legendary columnist Carson Brewer, who wrote often about the Smoky Mountain region and its inhabitants. It was about Lem Ownby, a nonagenarian who lived alone in a weathered old house—little more than a shack actually—located a short distance from the summer homes at Elkmont. From the article, I learned Lem was still an active beekeeper though his eyesight was completely gone. I was captivated by the whole idea of an old man living alone in the rugged mountains.

By this time, I was hiking frequently in the Smokies and had seen remnants of old homesteads and relics of times past scattered throughout the park, completely unaware that within a forty-five-minute drive from my home there was a living treasure. I had long wanted to meet the old character but

wasn't sure what the best approach would be. Would my long hair and beard be a disadvantage or a plus? Could I simply appear at his door uninvited? Would I be welcomed or shot?

Later that year, I was completing a hike on Jake's Creek Trail with some friends when the dense forest suddenly cleared, and we found ourselves staring at an unpainted, tumbledown house that probably looked much the same as it had for decades. The tin roof had oxidized to an interesting blend of bronze, copper and rust, the colors of oak trees in autumn. Black smoke billowed from the chimney. Firewood was piled helter-skelter on the front porch. A crosscut saw was hanging on the porch wall. Garden plots stood fallow, chicken coops empty. When I spotted the beehives, there was little doubt in my mind but that the weather-beaten, humble abode was Lem Ownby's place. Since it would be dark soon, and reasoning that we might not have another opportunity to meet the man that I considered a legend, we collectively decided to knock on his door.

It seemed so peaceful with the sweet melody of Jake's Creek playing in the background, and I realized the calming solitude surrounding the place had made me forget I'd just hiked several miles. Lem promptly responded to my somewhat reluctant rap with a "Who's there?" The screen door protested with a loud squeak as he pushed it open. The first thing I noticed was Lem's face. Despite his years, it looked—to use an old cliché—as soft as a baby's behind. That seemed atypical for an old, hardworking mountain man. The glint in his eyes belied the fact that he was blind. He looked comfortable in his bib overalls, denim jacket and scuffed brogans. After introducing myself, Lem said, "I know a lot o' McMahans, which bunch do you belong to?" Following a brief explanation of family lineage, Lem seemed at ease.

The single light bulb dangling from a cord in the center of his ceiling cast only a small circle of light; the room's dimness mattered not to Lem. Years of burning wood in the fireplace and then in the Warm Morning heater positioned in front of the hearth had left a nose-tingling smoky scent lingering throughout the house. I detected the sharp odor of chewed tobacco wafting from the tin can Lem used as a spittoon. The old clock on the mantle seemed to tick in unison with Lem's rocking chair as we sat and talked.

We sat spellbound while Lem told us about logging, farming, his family and even the weather. When we got up to leave, he followed us to the door and even consented to pose for a picture with me—a possession I cherish.

I noticed an active bee colony in the yard by the coal bin. "Do you still rob those bees?" I asked. "Sure do," Lem quickly replied. "I'm not able to do much farmin' anymore though," he added. Eventually, the subject of the

presidential election that was being held that very day came up. "Did you vote today," I asked. "I don't ever vote," he replied. "I bet you there's not two cents' worth o' difference in Carter or Reagan or any of them crooked fellers up there in Washington."

Our hunch that we might never have another opportunity to see the last living leaseholder of the Great Smoky Mountains National Park proved to be true. I was living in Nashville when Lem Ownby died a few years later on January 16, 1984. He was ninety-four years old. Due to the lasting impression he made on me, I felt compelled to continue learning whatever I could about the remarkable individual who became somewhat famous for choosing to live out his life in the only place he had ever known.

Lem Ownby never attained celebrity status like the Walker sisters of Little Greenbrier Cove, who were profiled in an April 27, 1947 issue of the *Saturday Evening Post.* Lem and the Walker sisters differed from many of those who sold their land holdings to the government and moved away. They were each in a unique situation with resources available right outside their doors from which to earn what they felt were adequate livings.

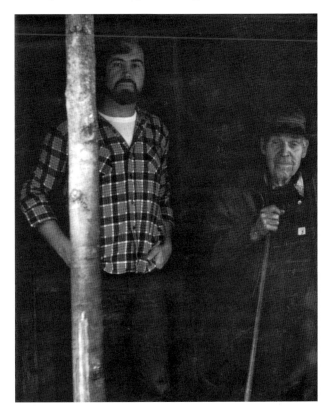

On November 4, 1980, I met the legendary blind beekeeper. We talked about his life in Elkmont, beekeeping and current events. *Author's private collection.*

Lem remained in his home long after his relatives and lifelong neighbors moved away. Contrary to some stories circulated about Lem toward the end of his life, he did not live the life of a recluse. He and his wife, Jemima (always called Mimmie and pronounced "my-me"), entertained frequent visitors, ranging from close relatives to complete strangers, often on their front porch. The couple kept abreast of current events, politics and family news.

Unlike those living on public land in the western states, who were constantly at odds with government agencies, Lem developed a rapport with the park service employees and became an unwitting public relations figure for a national park with the only negative aspect in its history being the relocation of reluctant mountaineers who never dreamed they'd have to leave their ancestral homes.

My mission in writing this biography is to record for posterity the life of Lem Ownby and solidify his rightful place in the cultural history and heritage of the Great Smoky Mountains that I so deeply love.

F. Carroll McMahan
August 2013

1
FROM WHENCE HE CAME

To be ignorant of what occurred before you were born is to remain always a child. For what is the worth of human life unless it is woven into the life of our ancestors by the records of history?
—*Cicero*

Lem Ownby's roots were planted deeply in the Smoky Mountain soil. In 1833, his great-grandfather John Ownby migrated to Big Greenbrier Cove, a beautiful valley situated along the Middle Fork of the Little Pigeon River. Traveling across the rugged mountains from Rutherford County, North Carolina, with his wife, Mary Jane Coone Ownby, and their eight children, he settled his family downstream from the Whaley clan who had lived in Big Greenbrier Cove since William Whaley settled there in 1810. The Whaley and Ownby progeny soon populated the valley.

In 1828, gold was discovered in Lumpkin County, Georgia, following various earlier gold strikes in North Carolina. According to oral tradition, John Ownby decided to move to the mountains of Tennessee thinking there might be gold yet to be discovered. Perry Shultz later claimed to have discovered gold and silver at the headwaters of Porter's Creek above Big Greenbrier Cove. He filed a claim and reputedly began a low-key mining operation in the area. Shultz fled when it was later discovered that he had been producing counterfeit silver coins. The location of the mine, if it ever existed, is unknown.

Although John Ownby never struck it rich, he remained in the area until his death in 1857 at the age of sixty-six. His widow, Mary Jane, who was

affectionately called Granny Coone by scores of grandchildren and great-grandchildren, outlived John by twenty-four years. She resided with various relatives until she died at the age of eighty-eight.

Born June 24, 1816, while his parents were still living in Rutherford County, North Carolina, David Ownby, the third oldest of John and Mary Jane Ownby's eight children, was Lem Ownby's grandfather. David married Eliza Ogle, a granddaughter of Martha Jane Huskey Ogle, who was the first settler in the White Oak Flats Community—White Oak Flats would later become Gatlinburg—when she moved there as a widow with seven children in 1811. David and Eliza married in 1840; he was twenty-four, and she was seventeen. They lived in White Oak Flats near Eliza's family and raised thirteen children, the fourth oldest being Thomas David Ownby, Lem's father.

The White Oak Flats Community officially became known as Gatlinburg in 1856 when a controversial storekeeper named Radford Gatlin established a post office in his store and chose to honor himself by naming it Gatlinburg. Doubtlessly, David and Eliza were in the thick of the feud that ensued between Radford Gatlin and Eliza's father, Thomas Ogle.

A heated confrontation that began as a dispute over the relocation of a road through the community arose between Tom Ogle and Radford Gatlin and his wife, Elizabeth. Both Radford and Elizabeth were indicted by the Sevier County grand jury for the assault and battery of Thomas Ogle on June 10, 1857. Separate trials were held in the circuit court.

At Elizabeth Gatlin's trial, Thomas Ogle testified that "she struck me in the hand with a stick she had been striking the cattle with, but when I came up she hit me in the hand with a pine stick and I jerked her on the ground. The defendant was striking at me several times with a stick and she hit me in the hand as I caught the stick." Mrs. Gatlin was convicted and fined one dollar.

Mr. Gatlin's day in court took place later and also resulted in a conviction. However, he was granted a new trial. It too resulted in a conviction and a one-dollar fine. The feud between the two families escalated when Gatlin appealed both cases to the Tennessee Supreme Court rather than pay the modest fines. The high court affirmed the decision of the local court.

Not long after the incident, Gatlin's barn and stables burned with his grain and horses inside, and his cattle were killed where they grazed. Gatlin quickly brought an arson charge against Thomas Ogle and his son Levi. But after a five-day investigation by the Sevier County grand jury, no indictments were handed down. The frivolous lawsuits against the Ogle family continued one

after another until Gatlin finally decided to leave town. In fact, he moved without ever paying his fines, leaving his bondsmen holding the bag.

Thomas David Ownby was born in White Oak Flats on October 29, 1846, making him about ten when the trouble between his grandfather Tom Ogle and Radford Gatlin was going on. A few weeks before his twenty-fourth birthday, Thomas David Ownby married Sarah Elizabeth Watson, daughter of David Corn Watson and Rachel Ogle Watson, who was another granddaughter of Martha Jane Ogle. In the remote mountains, it was not uncommon for cousins to marry cousins, which meant that practically everyone was somehow related.

It has been said that when a couple planned to marry, their parents would start "shaking the family tree" to ensure the relationship was far enough removed so as to be of no consequence. Cousins marrying cousins has also led to the saying that limbs on Smoky Mountain family trees didn't branch out all that far.

In 1843, David Corn Watson, then eighteen, moved to White Oak Flats from Oconaluftee in Haywood County, North Carolina, with his parents, John Watson and Susannah "Susie" Conner Watson. Along with brothers Sam, George, John, Henry and William, he served in the Union army during the Civil War. He and Rachel Ogle married on Christmas Eve 1846. Sarah (Lem's mother) was only eight when her mother, Rachel, died on October 18, 1859. Rachel died at the age of thirty-one, less than three months after the birth of her seventh child. The following year, her father, David Corn Watson, married Mary "Polly" Williams, and they had seven more children.

After Sarah Watson married, her father and stepmother moved from Gatlinburg to the Bird's Creek Community, located about seven miles northeast of Gatlinburg. In 1897, David and Polly donated the property for Shady Grove Baptist Church there. David Corn Watson died in 1913. Before his death, he made provisions for his estate to be divided among his fourteen children.

On October 6, 1870, Sarah Elizabeth Watson married Thomas David Ownby, and they soon moved to what was then known as the Little River Community. Perhaps they moved from Gatlinburg to settle on land that had been inherited by Thomas Ownby's mother, Eliza Ogle Ownby. The property was part of several thousand acres claimed by Eliza's father, Thomas Ogle. Other relatives were moving there, including two of Thomas's brothers, Stuart and Newton. Still others—such as Levi Trentham, who became known as the legendary "Prophet of the Smokies"—married into their clan. Levi Trentham married Thomas's sister Lithia Emmaline.

The area where Tom and Sarah settled is situated in a narrow but relatively flat valley created by the junction of Little River and Jake's Creek. Steep ridges surround the valley on all sides with Meigs Mountain rising to the west, Sugarland Mountain rising to the east and Cove Mountain rising to the north. To the south is Blanket Mountain with the slopes of Clingman's Dome and Mount Collins beyond.

The first known permanent settler in what is now Elkmont settled along Jake's Creek in the 1840s. There is little doubt Jacob "Jake" Houser was the creek's namesake.

By the time the Ownbys arrived, the area consisted of pioneer homesteads and farmsteads scattered throughout the valley, connected by trails and wagon roads. Levi Trentham constructed a tub mill near the confluence of Jake's Creek and the Little River, which was used by families for miles around.

On October 4, 1871, Dave and Sarah Ownby welcomed their first child, a son they named David. He was followed by another son, Burton Albert in 1873; a daughter, Lucy Luiza, in 1875; and another daughter, Mary Jane, in 1878. They had been married nine years when their fifth child, a son named John Wesley, was born in 1880. Joel "Bause" Bosdell came along in 1884, and Julia Mae was born in 1886.

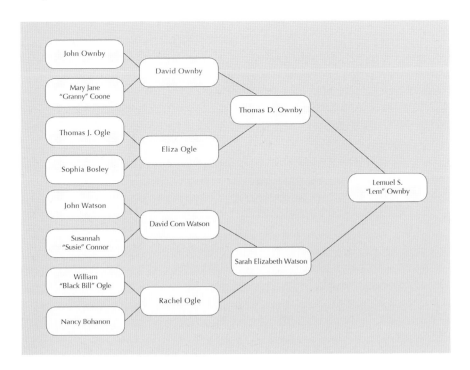

It was into an environment of hardworking, proud mountaineers that Lem Ownby made his entrance into this world in 1889. He was followed by another sister, Rachel Caroline, in 1891. The world into which Lem Ownby was born was devoid of even the simplest of modern conveniences.

There was no electricity, running water or indoor plumbing. The nearest post office was seven miles away in Gatlinburg, educational advantages were minimal and there were no doctors or medical facilities within reasonable reach. Summers were insufferably hot, and winters were bitterly cold. Life in the rugged mountains was often a daily struggle.

2
DEFYING THE ODDS

Life is a succession of lessons which must be lived to be understood.
—Helen Keller

L em Ownby was born, raised and lived out his life in one of the most beautiful spots on earth—the Smoky Mountains. For over three-quarters of a century, those mountains have been a national park—America's best loved, if the millions of annual visitors are any indication. Unless those visitors happen to tour areas such as Cades Cove (an eleven-mile scenic loop strewn with historic structures), the interpretive Mountain Farm Museum at the Oconaluftee Visitors' Center or the historic Cataloochee Valley area of the park, it might be difficult for them to imagine what life was like for the people who called the hills and hollows home so long ago. Most of the mountain families were large, self-sufficient and deeply religious. People were independent but sociable, and in order to survive in the remote mountains, they had to be resilient and industrious.

Illness and injuries were a part of life in the Smokies, and medical care was virtually nonexistent. There seldom was a doctor for miles around, but a community was fortunate if it had an individual known as a healer, who made use of herbal remedies. For the most part, mountain folk took care of each other and treated the sick and injured the best way they knew how.

Babies were almost always delivered at home, often with a close female relative assisting in the birth. Some communities were blessed to have one or more midwives—often called doctor women, aunts or granny women—who could be called on when it was time to bring a child into the world.

In the late 1800s, the average Appalachian midwife was skilled but usually lacked formal training. It was customarily at the foot of a bed observing her own mother or grandmother deliver a baby that a woman was trained to perform the task that would one day fall to her. Midwives often were paid with something the family had available on the farm: chickens, a sack of cornmeal or a basket of apples, perhaps. It was a lucky midwife indeed who received cash for her services.

The midwife summoned on Sunday, February 24, 1889, when Sarah Elizabeth Watson Ownby went into labor with her eighth child, was fifty-three-year-old Mary Adeline McCarter Quarrels. After hours of labor, a baby boy was born, and Granny Quarrels—as she was known by the Ownby family—was faced with delivering the sobering news: the baby was stillborn. Knowledge of resuscitation attempts has been lost somewhere in time, but it is safe to assume Granny Quarrels would have drawn on her experience and her familiarity with commonly used procedures as she sought to save the child. When those efforts failed, she collected her fee of fifty cents and quickly left the grieving family. With the infant mortality rate extremely high at the time, the granny woman's sorrowful pronouncement was heard all too often, especially in the isolated mountains; it was a brutal fact of life.

Amid a cruel blend of sobs and painful silence, the infant was laid out on a table to await burial preparations. The small cabin was crowded with relatives, including the baby's father, the seven older Ownby children—who ranged in age from three to seventeen—and various extended family members. It was the infant's uncle Stuart Ownby who happened to notice the little boy take a faint, shuddering breath. He loudly exclaimed, "Somebody better tend to that baby!" The household at once was abuzz as the shivering infant was swaddled in a warm blanket and placed in his mother's arms. The mood in the cabin lifted instantly with one tiny intake of breath. Everyone rejoiced that the baby boy was alive. Perhaps in gratitude for his keen observation, the child was named Lemuel Stuart after his uncle, whose alertness had prevented his newborn nephew from the horrifying possibility of being buried alive.

Both uncle and nephew had their names spelled differently throughout their lives with the first name being alternatively spelled Laymon, Lemon and Lemuel and the middle name Stewart, Steward or Stuart. The variations most likely can be attributed to the fact that neither received much education and couldn't spell or write their own names, thus relying on others to spell them.

The child was never called Lemuel or Stuart. From the beginning, and for the next nine decades, he was known simply as Lem Ownby.

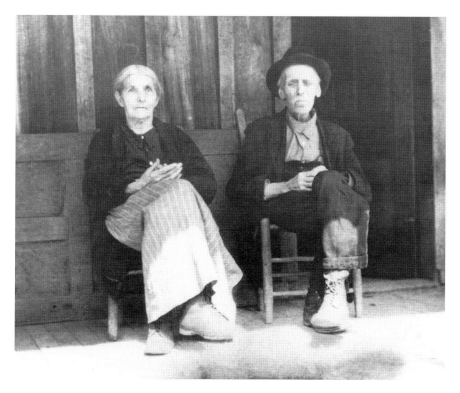

Lem Ownby's parents, Thomas and Sarah Watson Ownby, posed for a picture in the later years of their lives. *Courtesy of Winfred Ownby.*

In addition to his parents, living with Lem in the two-room cabin located where the famous Wonderland Hotel would one day grace the hillside were his siblings: Dave, Burt, Lucy, Mary Jane, John, Bause and Julia. Three years after Lem's birth, another daughter, named Rachel, arrived, making a total of nine children. By the time Rachel was born, the oldest son, Dave, was almost twenty.

The circumstances in which Lem Ownby was raised were comparable to most children living in the Little River Community and throughout the entire Appalachian region. Families lived in one- or two-room cabins, and it was not uncommon for a couple to have ten or more children. Like their relatives and neighbors, the Ownbys farmed the mountainsides and bartered for necessities in order to survive. Life was simple and hard.

Although children enjoyed romping over the hills and through the hollows, fishing, swimming, swinging from grapevines and playing games in front of the fireplace, they were not allowed to sit idly in their homes. There was

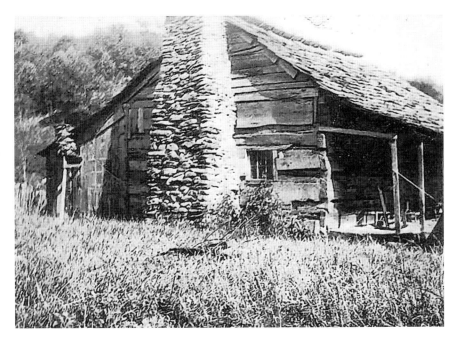

An old log house where Dave Ownby, Lem's oldest brother, lived in the early years of his marriage to Martha McCarter. *Courtesy of Winfred Ownby.*

too much work to do. It took every member of the family working together to make a living. Young boys began working in the fields as soon as they could see over the handles of a plow. Girls helped with cooking and other domestic chores in preparation for the day when they would get married and move to their own cabin. Duties such as planting and harvesting gardens and crops and milking cows were distributed equally between the sexes.

Boys started hunting for game at an early age to help feed the family. They were also taught the skills and proper time to slaughter hogs and prepare and preserve the meat. Girls were taught how to operate a spinning wheel, clean the cabin, cook, sew and preserve vegetables and fruits.

By the time Lem was three years old, his oldest brother, Dave, had married Martha McCarter. Lem became an uncle when his first nephew, Stephen, was born just one day after Lem's fourth birthday. As the older siblings married and left home, the workload just got heavier, and the younger children picked up the slack.

As if life weren't hard enough, as the males in the Ownby family grew older, it became apparent they suffered from a disease that affected their vision. First Dave started having problems with his eyesight and then Burt, followed

in succession by the younger brothers. Some of the boys seemed to have worse cases than others, with Burt having the most severe case. With no doctors in the community and no money to pay a doctor had one been available, the Ownby boys simply learned to live with the hands they'd been dealt.

Even if the best medical treatment had been available, the disease from which they suffered was not discovered until 1909 by Karl Stargardt, an ophthalmologist in Berlin, Germany. It was therefore given the name Stargardt disease, or *fundus flavimaculatus*. The disease is an inherited form of juvenile macular degeneration that causes progressive vision loss, usually to the point of legal blindness. The progression typically starts between the ages of six and twelve and plateaus sometime after a rapid reduction in visual acuity.

As in the case of Lem and his brothers, as well as at least one sister, the disease was almost fully developed by twenty years of age and included wavy vision, blind spots, blurriness, impaired color vision and difficulty adapting to dim lighting. Although they had no idea of proper diagnoses until they were adults, Lem and his brothers had classic cases of Stargardt disease.

By the time Lem was a young boy playing in the yard, he could not see well enough to avoid stepping in a mud puddle or tripping over a tree branch. Despite their limited vision, the Ownby brothers were still expected to work right along with everyone else in order to provide food and shelter.

Even though the mountain people were poor and lacked formal education, they were by no means the stereotypical ignorant hillbillies they often have been portrayed as. In fact, they possessed an ingenuity that allowed them to make the best possible use of their resources. Almost every family in the Little River Community established fruit orchards. They plowed gardens and planted crops on hills so steep they often joked that their mules needed to have two legs shorter than the others in order to stand upright on the slanted terrain. One man claimed he planted his potatoes in vertical rows instead of horizontal so they would roll right down the hill to him.

Along with corn, a variety of crops were raised for food for the family and for the animals. Families kept chickens for eggs and meat and for bartering for such items as tobacco, coffee, coal oil, etc. Throughout the Little River watershed, residents constructed gristmills for grinding their corn and wheat. It was often repeated among the mountain farmers that they "made do or done without."

A litany of innovative creations were conceived, built and used by the industrious mountain folk, all to make their difficult lives a little easier. For example, they built ash hoppers to funnel the lye out of ashes in order to make lye soap; they made kilns for drying fruit and poplar wood presses for

cider. If they needed a blacksmith bellows, they made it. If they needed a wood plane for smoothing their handmade furniture, they made that, too. A dough bowl carved from buckeye wood so it would withstand many washings was no problem. If they needed a basket for gathering eggs, picking berries or corralling sewing supplies, they made it from white oak splits or other woods readily available. For clothing and quilts, they used farm-sourced wool, cotton and flax. Many were truly talented and could even be called artisans. Creativity was often born out of dire necessity.

Social interaction was limited at best in Lem's early years. Most socializing consisted of visiting relatives on Sunday. Since the majority of the mountain people interpreted their Bible literally and just "didn't cotton to" working on the Lord's Day unless it was absolutely necessary—the cows still had to be milked, the livestock fed, the meals cooked—this practice of resting on the Sabbath allowed a few hours of leisure for checking on extended family, seeing the newest baby or catching up on the news someone might have heard while traveling to faraway places such as the courthouse in Sevierville.

Mountain families rarely had advance notice when visitors were coming. There were no means of communication to inform the host family. Visitors simply showed up. Unless it happened to be an unpopular relative, this was never seen as an intrusion or a burden; receiving these visitors was a highlight and a welcome break from their hardworking existence. As soon as Lem's mother saw company coming, she'd immediately set out preparing a meal for her guests. No matter how little she had, she could usually come up with something to serve, even if it were no more elaborate than honey on a cold biscuit.

When Lem was growing up, the nearest church was White Oak Flats Church in Gatlinburg. Getting there was a demanding seven-mile walk or horseback ride each way, so church attendance was rare. Most churches had to rely on circuit preachers who only made it to a church once or perhaps twice a month. On those days, people would pull out their Sunday-go-to-meetin' clothes, and the entire day was treated as a holiday.

The mountaineers didn't have much, but most were blessed with a good sense of humor. Florence Cope Bush, in her book *Dorie: Woman of the Mountains*, tells the story of a young man in the lumber camp who fell in love with a pretty young girl from Cades Cove who happened to belong to the footwashing Baptists. He was so much in love that he agreed to go with her to church. For a long time, he managed to escape the footwashing ritual, but his time was inevitable. He promised the next Sunday for sure. He lived in a boardinghouse with several men who just would not take his sudden interest in religion seriously.

On Saturday night, he bathed and laid out his clothes for the big Sunday. During the night some of his friends took his socks and poured soot into them, folded them neatly and put them back with his other clothing. He was up and dressed early. His friends followed at a distance as he made his way to church. The church service went well, and the time arrived for the footwashing to begin. All the men sat in chairs at the front of the church. Large pans of water waited at their feet. Each man was seated, put his feet in the water and, as a display of humility, another man washed and dried them. When the time came for the young man to participate, he sat down and removed his socks. He held them dangling in his hand while he stared, in horror, at his black feet. It looked like he had on another pair of socks. The soot covered him from ankle to toe.

Grabbing his shoes, he bolted to the door in time to see his bunkhouse friends hooting with laughter outside the church. Needless to say, the romance was dead. He'd never be able to face his girl again.

In the summers, highly anticipated revival meetings, usually consisting of a series of religious services, took place beneath a stand of big shade trees on someone's property and were conducted by a visiting preacher. Neighbors came from miles around to hear the hellfire and brimstone messages delivered with a vengeance. If attendees didn't believe in the Almighty when they arrived, they'd be afraid not to by the time the service was over.

Spirit-filled people shouted, spoke in tongues and ran up and down the aisles. One story circulated about a woman who, when she got to shouting, would get so excited that she'd toss her baby into the air. As the story goes, people were aware of this, and someone was always nearby to catch the baby. At the revival meetings, souls were saved, public confessions of sin—which sometimes shocked or amused the onlookers—were made and backsliding Christians rededicated their lives.

At the end of the revival, everyone turned out for a baptism in the river. Being washed in the blood often came with risks. Slippery, algae-coated river rocks, hypothermia—if they weren't careful—and water snakes were just a few of the perils of river baptisms.

Another mountain tradition was old harp singing. The notes of old, familiar hymns were sung from books brought from Ireland and Scotland generations before. In old harp, each note is represented by a different shaped note. Instead of singing the words, musical notes are sung. When a group of worshipers got together for an old harp singing, the haunting sound echoed through the mountains.

Occasionally, a family would travel all the way to White Oak Flats to attend church services, but that was not the norm. Most trips to Sugarlands (the area on today's U.S. Highway 441 about two miles south of Gatlinburg) or to Gatlinburg were taken by the men going to buy what few necessities they were unable to grow, hunt or manufacture at home. If a young man and young lady traveled that far together, it was usually to find a magistrate or preacher to perform a marriage ceremony.

Lack of accessibility to regularly scheduled church services did not prevent the folks in the Little River Community from living a wholesome Christian life. Dancing was frowned on, card playing was taboo and the consumption of strong drink was limited to medicinal purposes by the majority of the Little River folks who professed to live a righteous life. Moonshine stills were not uncommon, and the corn liquor made in them was handy to have around when treating some afflictions. There were exceptions of course, but the majority of Lem's family and neighbors were compelled to live their lives according to what they believed to be the divine and unquestionable word of God.

The one-room Little River School was established for students in the first to eighth grades while Lem was still young enough to attend without feeling awkward. Mountain schools typically were in session only a few months a year, yet Lem's attendance was still sporadic. It is highly likely that his reluctance to attend school was because of his impaired vision. However, he never used his handicap as an excuse later in life when reflecting on his childhood. He sometimes joked that he went in the front door of the school and out the back.

There were some children in the area that rarely or never went to school. Often, parents who were uneducated themselves failed to encourage a good education. Sometimes the need to have their children at home working on the farm simply outweighed the advantages of learning to read and write. If a child was kept in school, it was said their parents had "done a good part by him."

While Lem was still a young boy, Knoxville businessman John L. English began a small-scale logging project along Jake's Creek. To transport the logs to a sawmill on the outskirts of Knoxville, English constructed a series of splash dams along Little River. When the logs were ready to be moved, the floodgates of these dams were opened, and the rushing torrent carried the logs downstream. While English's attempt at logging was marginally profitable, a disastrous flood in 1899 wiped out the operation. The locals hated to see the logging venture fold because they had been hired by English

to fell trees, build the splash dams and transport the timber by mule-drawn skidders to the water. Although the wages had been meager, the income was sorely missed.

Since the Ownby family lived in the valley, it was not unusual for overnight guests to stop before crossing the mountains into North Carolina or going far up in the mountains to hunt. One of the most memorable overnight guests was Jasper Mellinger, a blacksmith from Roaring Fork, a settlement on the other side of Gatlinburg from the Little River Community. Mellinger stopped there one day before walking over to Hazel Creek, North Carolina. Although no one could later recall the exact date, Mellinger was never seen alive again. About two and a half years later, Mellinger's body was discovered by Lem's brother Baus and his Uncle Stuart. Identification was possible only because Mellinger's pocket watch, his rifle and other personal effects were found with his remains.

A few years after the discovery of Mellinger's remains, a young man in Wear's Valley fell ill and, on what he thought was his deathbed, confessed his part in the crime. He admitted that he and his father, John Beasley, had set a bear trap in violation of the law in the middle of the trail without posting warning signs.

When they returned five days later, they discovered Mellinger caught in the bear trap and almost at the point of death from injuries and exposure. He said his father ordered him to kill the unfortunate victim with a log. Reluctantly, young Beasley followed his father's orders, and the father and son together covered Mellinger's body with hemlock branches.

A second version of the story says Art Huskey and his son were accused, faced trial and later acquitted of the crime when a jury could not decide which man was responsible. However, Huskey's descendants disclaim this story.

Regardless of the true circumstances surrounding his death, the Jasper Mellinger incident was tragic. He left behind a family, and his widow spent the last years of her life at the Sevier County Poor Farm, a home for indigent residents.

Another man who sometimes spent the night with the Ownby family was William Robert "Bob" Catlett, a horse trader from Sevierville. Catlett often stopped there on his way to trade horses in North Carolina. A few years later, he was involved in one of the most high-profile murder cases in the history of Sevier County. Catlett was a member of a notorious vigilante organization called the White Caps.

The White Caps' original purpose was to rid the county of what it believed to be immoral activity, but members often used unlawful, violent

means to achieve their goals. On the night of December 28, 1896, Sevierville residents William and Laura Whaley were brutally murdered while their infant daughter slept in her crib. White Cap members Pleas Wynn and J. Catlett Tipton were convicted and sentenced to death by hanging for the crime.

Although evidence linked Bob Catlett to the crime and he was placed on trial several times, his wealth and resources allowed him to engage expert counsel. He was never convicted.

Many years later, Lem recalled, "Bob Catlett was a smart man who drove a lot of horses to and from North Carolina where he traded. Bob rode through here on horseback many a time and spent lots of nights here."

In 1901, Pennsylvania entrepreneur Colonel Wilson B. Townsend purchased eighty-six thousand acres of land along the Little River and established a business called Little River Lumber Company. By this time, the timber in the Allegheny Mountains was nearly gone, so Colonel Townsend had been drawn to the abundant supply in the Smokies.

MEIGS MOUNTAIN

Lem Ownby and his family relocated to a farmstead that lay in the shadow of Meigs Mountain when Lem was a teenager. Although other peaks in the Smokies have much loftier heights, Meigs Mountain rises 2,744 feet above sea level. The mountain was named in honor of Colonel Return Jonathan Meigs, a Revolutionary War veteran, surveyor, agent to the Cherokee Nation and military agent for the United States War Department. Meigs reputedly hung a brightly colored blanket atop the adjacent mountain, now known as Blanket Mountain, for use as a compass reference point.

Return was not a nickname. Colonel Meigs was given the unusual first name because of his father's relentless pursuit courting his mother. Meigs County, Tennessee, was also named in his honor.

Extensive logging by the Little River Lumber Company in the early 1920s left the mountain almost treeless except for hard-to-reach areas in the highest elevations. In the later years of Lem's life, hikers passing by his place on their way to Meigs Mountain Trail often stopped in to say hello to the old mountaineer.

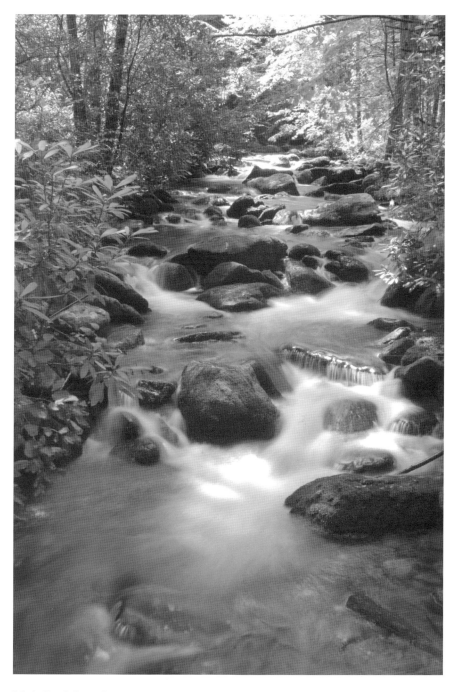

Jake's Creek flows down the mountain beside Lem Ownby's home. The creek's namesake was Jacob Houser, the first-known settler around Elkmont. *Courtesy of Richard Atchley Jr.*

In time, Townsend somehow worked out a deal with Lem's father, Tom, to acquire his place. Whether Townsend purchased the property outright and Ownby took the money and bought a farm above the mouth of Jake's Creek or they simply swapped property is unclear. Regardless, Lem, who was a tennager at the time, moved the short distance with his family and helped his father and brothers build a crude weatherboarded house where he would live for the rest of his life.

By the time the family relocated, not only had Lem's oldest brother married and moved out to start his own family but his oldest sister, Lucy, had married William "Willie" Cardwell and left the roost as well.

As soon as the Ownbys had a roof over their heads, they set out to cultivate their land. Although they were aware of the intentions Colonel Townsend had for the acreage he had accumulated, they probably had no idea just how much their lives were about to change. For better or worse, the residents of the Little River Community were on the verge of an unimaginable transformation. The scenic, gentle valley would never be the same.

3
ANOTHER WORLD

There are three constants in life…change, choice and principles.
—Stephen Covey

In 1908, Little River Lumber Company set into motion an enormous logging project along Little River's headwaters, namely Jake's Creek and the Three Forks area where the river absorbs Fish Camp Prong and Rough Creek. The Little River Railroad was extended all the way up the valley, with a logging camp and station set up at the confluence of Jake's Creek and Little River that was just "a hop and a jump" from the Ownby farm. The company named the town Elkmont.

The name Elkmont was not chosen because elk roamed the valley then or earlier. Beginning around 1900, members of the Knoxville Elks Club started camping and hunting in the area as guests of Colonel Townsend. Hence, the town was named Elkmont. An oft-repeated explanation told by those associated with the area at the time was that the town was named for the "two-legged" elks that roamed about the valley and not the "four-legged" animals that outsiders might assume.

Early Elkmont was a typical temporary logging camp. Shanty houses, a post office, a transient hotel, a commissary and sheds critical to railroad maintenance were the town's main buildings. Many loggers lived in boardinghouses while others crossed Sugarland Mountain using a trail connecting Elkmont to Sugarlands. Mountain men jumped at the opportunity for earning some cash. The average pay for a lumberjack was an astounding eighty-two dollars per month.

As logging operations progressed, it became necessary to move the camp higher and higher up the mountain slopes to the south. The company managed this by loading shanties onto railroad flatcars and moving them to preconstructed foundations using a logging crane. Although the logging camps moved, Elkmont was still used as a base of operations in the area.

Oblivious to the long-term negative impact the unrestricted clear cutting would have on the environment, most of the locals welcomed the Little River Company, which provided income to clothe and feed their families. Most of the able-bodied men and older boys soon went to work for the company, including Lem and his brothers and cousins.

"A good day's work meant cutting 15 trees with a two-man crew on a crosscut saw and a leader. The leader by the way was an important guy. He determined which way the tree would fall," recalled Lem in an interview with Jim Dumas, a reporter for the *Sevier County News-Record*, who was conducting an interview for an article in 1982.

In the article, Dumas reported that Ownby received $1.50 for each day's labor, a full eleven hours. As it does now, the Little River area abounded in towering beech and ash trees. Countless loads of trees were snaked to the landing docks by workhorses or oxen and placed on flatcars to be hauled to market by a puffing steam engine.

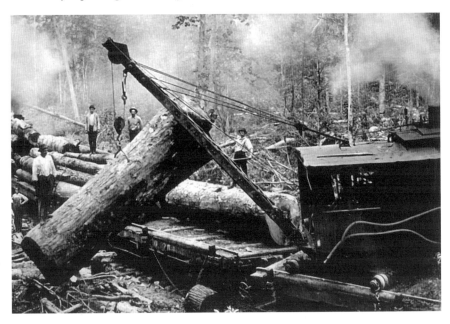

Once the Little River Lumber Company was established in Elkmont, thousands of acres of ancient timber was cut down in a few years. *Courtesy of Great Smoky Mountains National Park.*

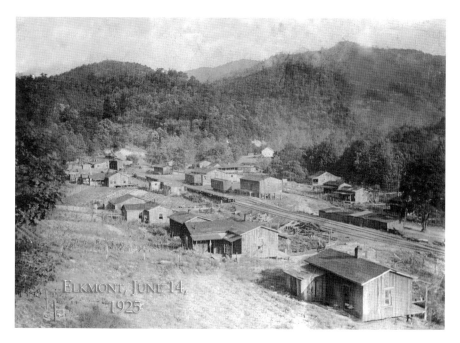

Elkmont in 1925. *Courtesy of Great Smoky Mountains National Park.*

Ownby, of course, did not keep count of the hundreds of trees that he and his crew cut, but he vividly remembered the largest. Asked by Frank Watson, a cousin and longtime friend, to tell about the biggest tree he saw felled, Lem replied, "Grand daddy of 'em all. Old Granddad was a great big poplar, nine feet around. You'll never see flatcars with logs like that again."

Some of Ownby's first employment duties for Little River Lumber Company consisted of clearing rights of way for the tracks that extended from the Little River wilderness to Knoxville. He also recalled driving oxen teams in snaking logs to the waiting trains.

In the Smoky Mountain Historical Society's book, *The Gentle Winds of Change*, Lem and Burt are named as well-remembered sawyers of the era. Both were almost blind, so the chipper would get them started to ensure they were "cutting square." Earl Franklin recalled that the Ownby brothers "were remarkable workers. It didn't make no difference how big a tree was. When they laid their saw up across that log, they didn't stop one time till it went out the bottom."

Dr. Benjamin Bruce Montgomery had a medical practice set up at the lumber camp and was always ready to tend to anyone who needed treatment. One of Lem's few trips to a doctor's office was forced by an abscessed

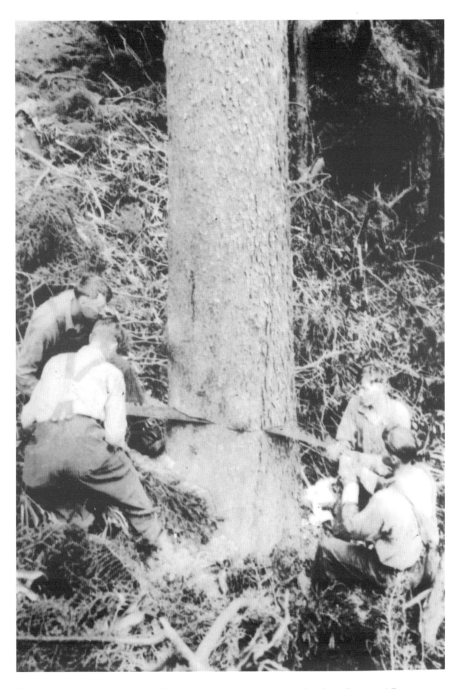

Loggers cutting down a tree with a crosscut saw, the same job brothers Lem and Burt Ownby had. *Courtesy of Great Smoky Mountains National Park.*

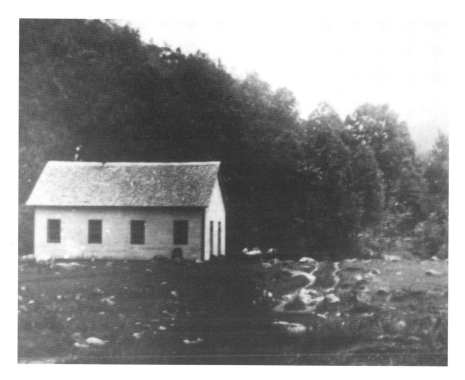

Elkmont Baptist Church was dismantled and rebuilt in Wear's Valley in 1938. It has since been renamed the Elkmont Chapel. *Courtesy of Great Smoky Mountains National Park.*

tooth. "This tooth was giving me a fit," recalled Lem. "So I gave in and went to Doc Montgomery's office. When he pulled that tooth blood just flew everywhere." Dr. Montgomery exclaimed "God-a-mighty Lem, it's a wonder it hadn't killed you." Lem remember there were other doctors who made house calls by horseback or cars, but his favorite was Dr. Montgomery.

While the days were long and the work hard, leisure time—what little they had—was enlivened by entertainment such as movies projected onto a big screen in the commissary, transportation on the train and an opportunity to meet folks from other areas who came to Elkmont to find work.

The few worldly activities available were somewhat tempered by the community church. Established in 1916, Elkmont Baptist Church was the social center for most of the longtime residents who had long wanted a house of worship of their own. Holding steadfast to their upbringing, dancing was forbidden, as was alcohol consumption and card playing.

One of Lem's favorite stories concerned a preacher who preached the "straight and narrow." According to Lem, there was the typical share of

whiskey drinkers in the logging community. "There was this young man in the camp who everyone called Troy Dog. And one day somebody asked Troy Dog about the new preacher. Troy Dog replied, 'I never heard him preach but they say he is a hell of a preacher.'"

In 1910, the earth passed through the tail of Halley's comet. The anticipation of its arrival caused quite a stir in Elkmont. Impressionable people saw it as a sign of impending doom. The comet was at its closest, and therefore its brightest, from May 14 to May 22, 1910. "The end of time is coming for sure," predicted some of the loggers. Lem went about his business as usual, telling the doomsday forecasters, "You better go ahead and salt a little something away, just in case you're wrong."

During the early days of the logging town, Lem was still single and remained close to home and family. Reminiscing in his later years, he said that he had never been farther west than Knoxville and had only been out of the state of Tennessee one time when he walked over to North Carolina to "see a feller about a dog." He also mentioned that he traveled to Sevierville a few times on business and rode the train to Knoxville on rare occasions. Lem was almost twenty when the railroad from Townsend to Elkmont was completed in December 1908. The first trainload of logs from above Elkmont was delivered to the sawmill at Townsend in January 1909.

Timber cutters had been at work in the river valleys above Elkmont for several months. Horse teams snaked logs out of hollows and down from slopes as they were cut. There they were left to weather until rails could be laid to where they were stockpiled. By early summer of 1909, there was a steady daily movement of timber to the mill from the watershed of Jake's Creek.

Everyday passenger service from Knoxville to Elkmont began on July 5 with a crowded train and a great outpouring of local people to meet it. Little River Lumber Company employees and their wives and children joined families who had lived along Little River or across the mountain in the Sugarlands. On that hot, humid day, the commissary sold thirty gallons of ice cream before running out.

Aside from picnicking and swimming in the cold mountain streams, people seemed to gain a great deal of excitement viewing the remains of a train wreck that lay in a ravine. It was the wreck that killed engineer Gordon A. "Daddy" Bryson and Charles M. "Charlie' Jenkins in 1909.

Engineer Bryson and brakeman Jenkins were killed in the wreck of the locomotive and flatcars heavily loaded with logs. A theory of the cause was that the sand reservoir was clogged, and without sand for braking traction,

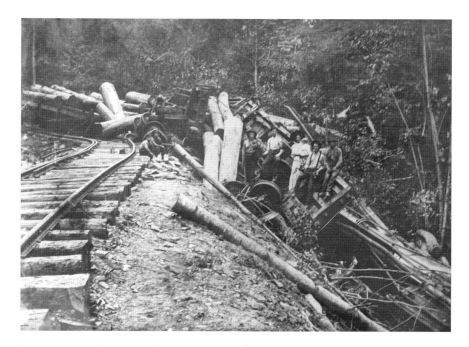

The wreckage of where Gordon "Daddy" Bryson and Charlie Jenkins died in 1909. *Courtesy of Great Smoky Mountains National Park.*

the train ran away and jumped the rails on the steep downgrade. Several men jumped from the train unhurt.

It was a custom in logging camps to hang the dinner buckets of accident victims from a tree (the noon meal was referred to as dinner). Bryson's and Jenkins's dinner buckets hung from a tree in Elkmont for many years.

Despite the tragedy, life went on. Meanwhile, several poems, some of which were set to music, were written commemorating the wreck. One such rendering is titled "The Ballad of Daddy Bryson."

Possibly because he was witness to the tragic event, Lem loved the ballad. He memorized the words and would sometimes sing the conclusion for his family or visitors.

> *Down the hills on Jakes Creek*
> *This wicked train did run.*
> *Till the brakeman and conductor*
> *Saw there must be something done.*

Poor brakeman Charlie Jenkins
His last words did relay
"I hope nothing will happen
On the last trip we make today."

The engine speed increasing
Forrester picked his place and jumped.
There was a mighty crashing
As he landed on a stump.

Old three spot she turned over
And the tank by Daddy passed.
The logs fell upon him
Poor Daddy breathed his last.

Although the tunes never gained popularity like "Casey Jones" or the "Wreck of the Old 97," they certainly became a part of Smoky Mountain folklore.

This wasn't the only wreck or incident in the mountains involving trains, nor was this the only one that resulted in death or injuries. Engine Number 1 derailed into the river near Townsend sometime around 1901; Number 4 Shay (named for inventor Ephraim Shay) fell through a bridge at West Fork in 1904, though it was later repaired; Number 9 Shay experienced a boiler problem and the cab separated; Number 4 Shay had a boiler explode in 1914, killing fireman Sam McClanahan and injuring engineer Walter Hall; and a caboose derailed in 1917 killing J.N. Badgett, Pleas Myers and Earl Dockery. Interestingly, in 1931 when the Number 9 and Number 11 Shay engines became unusable, the boiler of Number 11 was put into service at a school in Townsend for a heating plant.

In 1926, Colonel Townsend sold most of his Little River Lumber tract to the federal government for the purpose of creating a national park, although he was given permission to continue logging for most of the next decade. By the time the company ceased operations in 1939, it had produced 750 million board feet of lumber and left the Smokies with scars that would take many decades to heal.

Opposite, top: The Wonderland Hotel as it appeared when its doors were opened in 1912. *Courtesy of Great Smoky Mountains National Park.*

Opposite, bottom: The Elkmont Post Office during the heyday of the lumber camp. *Courtesy of Great Smoky Mountains National Park.*

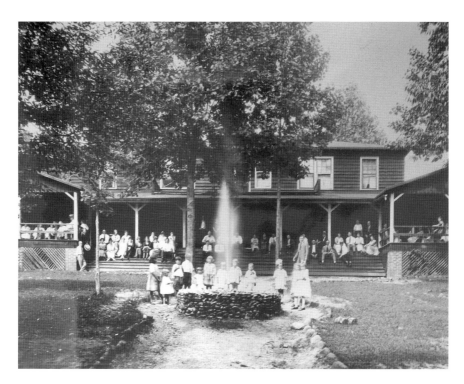

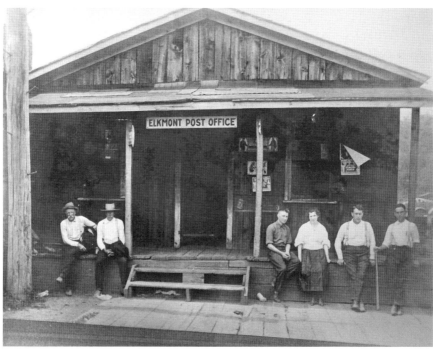

After slowly stripping Elkmont valley of its valuable timber, Colonel Townsend began to advertise the area as a mountain getaway. As early as 1909, Little River Railroad began offering the seasonal "Sunday Elkmont Special," a nonstop train service from Knoxville to Elkmont. Tickets sold out quickly, and the service was eventually extended to several days per week.

As Little River Railroad's Shay engines proved too slow for passenger service, the company employed a ninety-ton Mallet and a Pacific engine to pull the passenger cars. In 1911, Townsend gave Charles Carter several acres of land, which included Lem's birthplace, that overlooked the town of Elkmont with the stipulation that Carter build within a year. In 1912, Carter made good on the promise when he opened the Wonderland Hotel. Billed as a resort lodge, the hotel contained fifty rooms with an extensive balcony overlooking Elkmont and Meigs Mountain. The new hotel was open from June 1 through October 10 every year and was constantly booked in its early years of operation.

The mountaineers knew this hotel and others, such as the Tremont Hotel, catered to a different socioeconomic class. Unless they were employed in the hotels, the mountaineers knew the businesses were pretty much off limits. It must have bothered some people, this separation, though most had the mentality that if they weren't welcome somewhere, they just stayed away. Even with their fierce sense of self-worth, the homespun-clad mountain women sometimes must have felt inferior to the elegant city ladies who frequented the hotels dressed in their finery.

The Wonderland Hotel was a welcome site to those who could not gain acceptance into the Appalachian Club. The group purchased several acres of land just below the confluence of Jake's Creek and Little River about a half mile from the Ownby homestead. There, they built a clubhouse and around forty rustic cabins for use as summer residences.

Membership in the Appalachian Club proved difficult to obtain, and several Knoxville residents who had been rejected for membership purchased the Wonderland Hotel site and formed the Wonderland Club. No longer open to the public, the transient hotel used by salesmen and loggers was refurbished for tourist use and remained open year-round.

On Saturday June 30, 1917, the recruiting officer for the Third Tennessee Infantry arrived in Sevierville to sign up volunteers. It didn't take long to determine that volunteers would not be enough to fulfill the needs of the U.S. Army to serve in Europe during World War I. Therefore, the government devised a plan whereby all the country's men were registered and given physical examinations. Each county was assigned a quota based on the

number of registrants. Lem, of course, was granted an exemption due to his partial blindness, as were his brothers. Lem also received an exemption by the Sevier County Election Commission from paying the required poll tax in order to vote.

In 1925, Little River Lumber Company ended its logging in the area above Elkmont and sought to move the Elkmont tracks to Walker Valley (now Tremont). Fearing a lawsuit from the influential Appalachian Club members, Colonel Townsend ordered the tracks to be pulled up and moved in secret, while the summer people were not in residence. Naturally, the Appalachian Club members were outraged. Fortunately, however, the railroad grades were perfect for road construction. Thanks largely to Tennessee governor Austin Peay, who owned a cabin at Elkmont, a road was constructed connecting Townsend with both the Wonderland Club and the Appalachian Club areas.

The days of logging had passed and the era of the summer resort was approaching. For the same reasons—primarily economic—that locals embraced the lumber companies, they also welcomed the summer residents. Not only did the resorts hire men as caretakers, they also needed women for the domestic duties. This was one of the first opportunities the mountain women had to earn salaries outside the home.

Once again, Elkmont was in transition. The rough-and-tumble lumberjacks had been replaced by a genteel group from high society.

4
BREAD AND BUTTER

Even if I knew tomorrow the world would go to pieces,
I would still plant my apple tree.
—Martin Luther

Once the loggers came to Elkmont, much to the excitement of the mountain girls, there was a new pool of eligible bachelors. To the chagrin of the young men, however, the number of girls looking for husbands dwindled fast. There were a few daughters of the nonlocal loggers who were of marrying age, but the odds were stacked against the men.

Due to his diminishing eyesight, Lem felt as if he were handicapped when it came to finding a suitable mate. When he turned thirty, Lem continued to hope for a partner, but his expectations were rather low. The potential for finding a bride around Elkmont was very limited.

When asked how he met his wife, Lem said, "A feller had recommended her to me and I wrote her for a year or so before I met her." Actually, someone had written the letters on Lem's behalf as he couldn't write well enough. "She did pretty well living up to my expectations when I first saw her as she was going into church. We got to corresponding a little and courted for three more years before we got married."

The woman who accepted his proposal of marriage was Jemima Ownby, who grew up east of Gatlinburg at Dudley Creek. She was always called Mimmie. Although Lem and Mimmie never met while growing up, they were actually third cousins once removed.

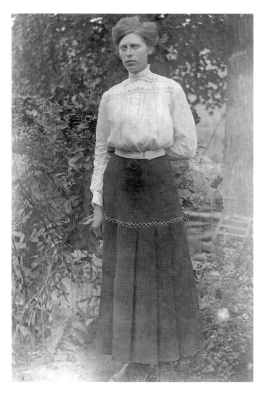

Jemima "Mimmie" Ownby as she looked around the time she married Lem Ownby. *Courtesy of Theresa Williams.*

Mimmie was one of eleven children of Braselton Ownby and Mary Ann "Polly" Ownby. When she was three years old, Mimmie's mother was pregnant and craving squirrel gravy, so her husband headed out to shoot a squirrel to fry up so that she could make gravy from the pan drippings. Mimmie's mother never got her squirrel gravy, though, because Braselton Ownby accidentally shot himself.

Not long after he'd headed into the woods searching for a squirrel, Braselton came upon a log lying across his path. As in times past, he placed the butt of his gun on the log to brace himself. He put one foot on top of the log and then the other. To his surprise, the log was rotten; one foot went through the log up to his thigh.

Trying to maintain a steady balance, he waved his arms in the air. The butt of the gun that he held in his right hand hit the log. The gun fired, and the bullet lodged deep in his abdomen. His wife and children heard the gunshot, and the older children ran to investigate. They soon found their father, dead. Grief stricken, the children returned home to relay the sad news to their mother.

The shock of Braselton's death fell heavily on Mimmie's mother, Polly. Losing a husband would have been tragic in itself for an expectant mother, particularly one with nine children to support, but things only got worse. The emotional stress brought on by the accident resulted in a premature delivery, and Polly soon found herself coping with not one death, but three. She had given birth to twin girls, Etta and Alice, both of whom died shortly after delivery. Mimmie would remain the youngest of the nine surviving children. It was into this emotionally charged environment that she was raised by a single mother with the help of older siblings.

By the time Lem and Mimmie started corresponding, they were both past thirty years old. In the mountain culture in which they lived, she was considered to be an old maid, and he was said to be an old bachelor. In a conversation in his later years, Lem was asked about trying to find a suitable wife. "We couldn't be choosey about the girls," he said. "There weren't many of 'em. So we took whatever was available."

Lem and Mimmie were thirty-five when they finally exchanged wedding vows. Born April 11, 1889, Mimmie was about six weeks younger than Lem. They were pronounced man and wife by Reverend Otha Ownby in a simple ceremony held at the preacher's home in Gatlinburg.

Lem brought his new bride to his home at Elkmont, which they shared with his aging parents. Although it is certain that word of the marriage sped throughout Elkmont, the newlyweds were spared the indignity of a traditional shivaree, a mountain custom in which the couple is taken from their bed on their wedding night. The men would place the groom astride a rail and carry him around the neighborhood all the while laughing and cracking jokes. Afterwards, the red-faced groom would be returned to his bride and refreshments would be served. Perhaps Lem and Mimmie were spared because of their age or possibly because of Lem's limited eyesight.

When Mimmie saw Elkmont for the first time, it was a busy logging town with crude buildings scattered everywhere. The hustle and bustle was quite

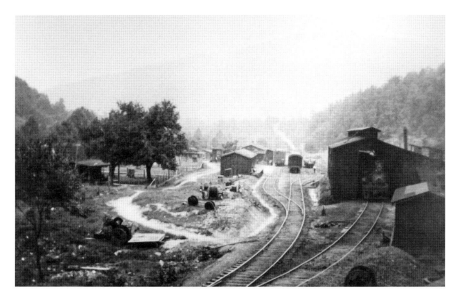

Mimmie Ownby's first view of Elkmont when she arrived there in 1924. *Courtesy of Great Smoky Mountains National Park.*

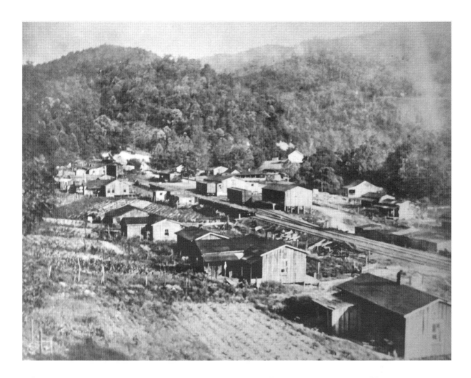

Elkmont was a bustling logging town in 1925 with a church, theater, post office and mercantile store. *Courtesy of Great Smoky Mountains National Park.*

different from the tranquil life she enjoyed on Dudley Creek. However, she made the necessary adjustments and lived in the same house for the next forty-three years.

One advantage Mimmie found in her new home was "running water." After Lem's sisters married and left home and therefore were unavailable to carry water, he devised a system to supply water from a spring located on the side of the mountain several hundred feet from the house. He installed a galvanized pipe that emptied into a wooden trough, and they were able to enjoy at least one "modern" convenience. The end of the pipe had a wooden plug to hold back the flow of water. When it was removed, icy cold spring water flowed right up to their back porch.

When Mimmie arrived, both of Lem's parents were in their seventies. She became partially responsible for the care of her in-laws in addition to other household duties. Tom Ownby passed away in 1930, and Sarah Ownby died in 1931. After more than five years of living with his parents, Lem and Mimmie had the family home to themselves. By this time, they were forty-two.

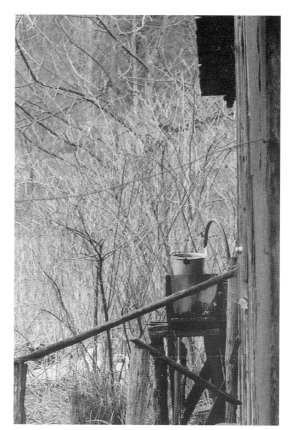

Right: Lem Ownby made sure his house had running water, piping it from a spring. A wooden plug at the end of the galvanized pipe was removed, letting cold spring water flow into a wooden trough on the back porch. *Courtesy of Elizabeth Ballard.*

Below: Mimmie rolled her wringer-type washing machine over to the water supply on wash days. *Courtesy of Elizabeth Ballard.*

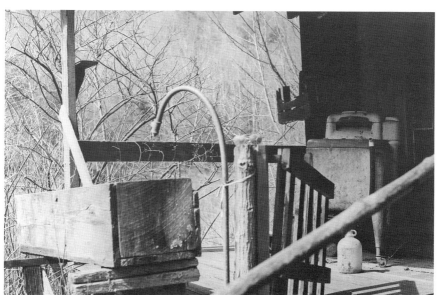

MIMMIE'S HONEY COOKIES

2 cups self-rising flour
1 teaspoon ground ginger
¾ cup sugar
½ cup honey
3 tablespoons of butter
¾ tablespoon vinegar
1 egg
Milk to make desired consistency

Combine dry ingredients and set aside. Cream honey, butter, vinegar and egg. Carefully add flour mixture to wet ingredients and mix well. Add enough milk for typical cookie dough. Drop by spoonful onto greased baking sheet, leaving space for cookies to expand. Bake at 350 degrees until brown. Watch carefully so you do not over bake.

Perhaps because they never had children of their own, Lem and Mimmie were close to their many nephews and nieces. Theresa Williams, a grandniece of Mimmie, recalls many visits to Uncle Lem and Aunt Mimmie's house. "The minute we arrived, Aunt Mimmie would head for the kitchen to see what she could rustle up to eat," Theresa said. "If she wasn't cooking at the time, she'd warm up whatever she had left over from the last meal. It was always good." Mimmie loved to bake cookies with the younger members of the family. Her nieces and nephews were especially fond of "Aunt Mimmie's honey cookies," a recipe in which she substituted some of the called for granulated sugar with Lem's honey. "There was nothing better than Aunt Mimmie's mouth-watering honey cookies served piping hot when they were taken from the oven of her old wood cookstove," remembered Theresa. Mimmie baked her cookies in a wood stove, but Theresa adapted the recipe for electric ovens.

Mimmie made good use of the abundant apples Lem harvested from the orchard. Because they were so plentiful, she made numerous jars of apple butter to have on hand throughout the year. She also dried apples for pies, cakes and other desserts. Apples were also sold for much-needed cash

While Mimmie took care of the domestic duties, Lem worked on the farm. He quit his job with the Little River Lumber Company several years

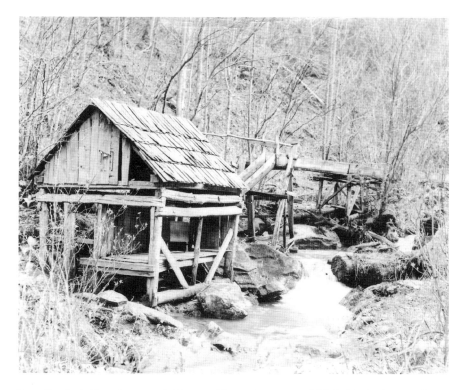

Lem Ownby built and operated this tub mill over the waters of Jake's Creek. *Courtesy of Winfred Ownby.*

before the logging ended at Elkmont in protest over his displeasure in a piece of equipment he felt was inadequate. He simply said, "If they can't do any better than this, I'm goin' home." And he did.

There was plenty of work to be done on the farm. The orchard consisted of 180 fruit-bearing apple trees. He cultivated land for crops such as corn and tobacco, raised livestock, fished for trout and operated a tub mill on Jake's Creek. Not only did he grind his own corn and wheat, but Lem also ground grains for others who didn't have a mill of their own.

At one time, several tub mills were located along Jake's Creek. Winfred Ownby remembers his father, Stephen, telling about when his father, Dave (Lem's older brother), sent him to have his corn ground. "Son, be sure and go up to Uncle Levi Trentham's mill because your Uncle Lem will charge you too much," the elder Ownby said. Lem was always known for his frugality.

Lem was an avid bear hunter. It was not uncommon for him to return from a hunting trip with numerous bearskins draped across his shoulders.

He would sell the bearskins for top dollar, providing much-needed cash. An incident that occurred on one of his hunting trips has garnered many laughs for generations of the Ownby clan. Lem was in the mountains with his nephew Steve Ownby, and they had a bear treed. He laid flat on his back on the ground at the base of the tree, directly under where the bear had climbed. He wanted to get off a good shot.

Just as Lem cocked his gun, the old bear answered a call of nature, covering him in bear scat. Disgusted and embarrassed because he knew his amused nephew would tell everyone he knew, Lem exclaimed, "I thought I had seen and done just about everything there was to do, but this is the first time I've ever been shit on by a bear."

In the waning logging days in the Elkmont environs, a blowhard logger named John Williams gained a good deal of notoriety when he decided to learn to fly an airplane. Williams, who was known by the unusual moniker Rooster, was tall, muscular and sometimes intimidating in physical appearance. Most of his friends were careful what they said to him and when they said it. This was especially true when Rooster had been drinking, which was said to have been often.

Rooster became infatuated with the idea of flying when Frank Andre of Knoxville landed a Standard biplane at Elkmont for the first time in 1923. Rooster met Andre that day and talked with him about teaching him to fly. They worked out a deal, and Rooster traveled to Knoxville for weekend instruction from Andre. Sometimes, he made the trip by train through the Little River Gorge and Townsend to the connection with Southern in Walland. Other times, he drove his Star automobile through Fighting Creek Gap, Gatlinburg, Pigeon Forge and Sevierville.

Much to the amusement of his fellow lumberjacks, Rooster purchased an army surplus Jenny training plane left over from World War I. He said anybody that could operate a steam donkey engine or run a locomotive could fly an airplane. The plane arrived in a wooden shipping crate ready to be assembled. He had to buy the wings and install the Curtiss OX-5 engine. Rooster somehow persuaded Andre to assist in the assembly, including stretching the Irish linen over the fuselage skeleton and wings.

Acquaintances wondered how Rooster was able to afford an airplane—he'd paid fifty dollars for it—flying lessons and a nice car on a logger's pay. It was said that Rooster made whiskey during those Prohibition days with a wink from one of the company's managers.

Rooster shipped the plane to Townsend on two railroad flatcars where he and Andre put it together. Once it was assembled, Rooster took leave of his

job at Elkmont for three days to have time to fly paying passengers. They flew under the Gay Street Bridge in Knoxville and around tall buildings before heading off toward the mountains. Stopping along the way, they charged anyone who wanted to experience the thrill of flying the exorbitant fee of five dollars. He then wanted to take his plane to Elkmont, not only to offer rides but also to show off the plane that he had boasted about for so long.

As bad as he wanted to take the plane to Elkmont, he wasn't sure he was ready to fly it into the valley between high mountains. Again, he called on Frank Andre to come from Knoxville to help him. Andre reluctantly agreed to fly the Jenny to Elkmont but extracted a promise that he would not be asked to fly it out again.

An announcement had been made beforehand that Andre and Rooster would be flying in on a certain day. The crowd whistled and cheered when the plane landed safely in the area that is now part of Elkmont Campground. Although Lem and his wife were aware of all the commotion, they chose not to walk the short distance to witness the event. However, when the plane landed, they were close enough to hear the engine's whine from their home.

Andre's parting advice was for Rooster not to try to take off from there before putting more dope on the linen covering to make it waterproof and more taunt over the airframe. But there was a certain feeling among those who knew Rooster well that he would try to fly the plane at the first opportunity, perhaps on the next Sunday, when all the loggers were off work. It was in that atmosphere of expectancy that a crowd gathered to watch what would soon become Rooster Williams's first and last flight from Elkmont.

Rooster's wife, Maude, and their son, Ben Mack, had arrived early, indicating Roster planned to fly that day. Maude said that when Frank Andre gave Rooster flying lessons it excited him more than anything she had seen happen to him. And now that he was in the cockpit at the end of the take-off strip, she braced herself for the worst but hoped for the best. She knew he had been drinking that morning.

Two men who worked with Rooster on the loading crew during the week went along to help start the airplane's engine. One of them "pulled through" on the wooden propeller. Rooster sat in the cockpit and nursed the throttle, choke and ignition controls. A friend kicked away the rocks in front of and behind the wheels. Meanwhile, two of Rooster's friends held a long fence rail against the landing gear above the wheels to hold the plane back while he revved the engine.

At Rooster's signal, they quickly withdrew the rail, and he went bouncing down the field, heading for an open space beside the church, hoping to be

airborne in time to clear a big boulder at the end of the strip. He did get the plane off the ground, but it didn't clear the rock. One wing tip grazed the boulder, and the Jenny came to rest leaning on its nose and one crippled wing.

The only injury was Rooster's pride. The plane stood there so long that bees stored honey in the radiator comb. Rooster dismounted the engine and laid it on his porch until finally he took it to a garage in Sevierville. Word got around that he had installed the engine in a car and planned to race it. When asked how fast the car would go, his reply was "faster than the word of God." It must have gone pretty fast for Rooster was injured later in a car wreck near Townsend.

Talk of the "Flying Rooster" continued for years with people who were present, those who weren't there but claimed to have been and others who merely had heard about it. Naturally, many of the tales were exaggerated with the retelling. Discussions about Rooster Williams often took place on Lem's front porch, although Lem thought it was all a "bunch of tom foolery."

Gossip about Rooster Williams did not end with the aborted airplane takeoff. After this, Rooster left the mountains to run a log loader on a ponderosa pine sawmilling operation in the mountains of southern New Mexico. He met a woman there and later mailed Maude some papers saying that he had been granted a divorce. Later, he wrote Maude again and told her he was coming home. He said he was lonesome for his family, meaning her and his son, Ben Mack, who by then was married with his own family. But he never saw home again. Perhaps because he was planning on leaving her, his new wife shot and killed him.

When the logging camp pulled up stakes and people moved out as quickly as they had moved in, those who called Elkmont home before the logging company was established had to decide whether they wanted to stay there and go back to the days of grubbing out a living on the unforgiving hillsides or move somewhere they could earn a living working for someone else.

The decision was easy for Lem and his immediate family. They would stay put. After all, their family had lived off this land for generations. But another impediment to living an agrarian lifestyle in the Little River Valley loomed large on the horizon. Since the Little River Lumber Company came to an agreement with the government, it was just a matter of time until the large holdings that Colonel Townsend once owned, as well as thousands of acres in the hands of other lumber companies and private land owners, would become federal property.

Rumors spread rapidly around Elkmont and other communities throughout the Smokies about what lengths the government would go to in

order to establish a national park. Some residents were more than willing to accept an offer if approached, thinking they could take the money and relocate some place where living would be easier than the hardscrabble lifestyle they had always experienced in the mountains.

There were others who felt it would be devastating to be forced to leave the only home they had ever known. They couldn't fathom leaving the place where they were born and raised and their ancestors lay buried. With the help of family, Lem planted crops and a large orchard, acquired additional livestock and managed to make a living on his little piece of paradise. He thought because the government moved so slowly, if a national park ever did materialize, it would take so long that he would be dead and gone long before it ever came to fruition.

As Lem's father, Tom, had passed away on July 25, 1930, and his beloved mother nine months later on April 5, 1931—both were laid to rest in the little Levi Trentham Cemetery a short distance from the family home—this gave Lem still another tie to Elkmont. He had no plans to leave.

THE SUMMER PEOPLE

Every moment and every event of every man's life on Earth
plants something in his soul.
—Thomas Merton

Once the railroad connected Elkmont to Knoxville, adventurous Knoxville gentlemen of means caught on quickly. They boarded the Southern Railway's Knoxville and Augusta Railroad affiliate and rode to Walland, where they transferred to Little River Railroad's logging train. They rode in a caboose and got off at Elkmont, and the train continued up Jake's Creek to the logging camps. The weekend trips became so popular that their wives became curious and eventually joined in the excursions.

The first big summer for the Knoxville crowd was 1908, when the Appalachian Clubhouse was built. Colonel Townsend, who let the club have the acreage for its site and for the adjacent log cabins, added an observation car on the logging train and later added passenger coaches.

Both the Wonderland Hotel and the Appalachian Club flourished. Vacationers came from Knoxville on a torturous trip that took between two and a half and four hours. Elegantly dressed passengers stepped off the platform at Wonderland Station. They checked into their rooms or their cabins and spent the weekend, or months, enjoying the cool mountain air, delicious food prepared by local women and social gatherings inside the clubhouse or on the front porch in rocking chairs. Only members or guests of an acceptable social circle were served in the Appalachian Dining Room.

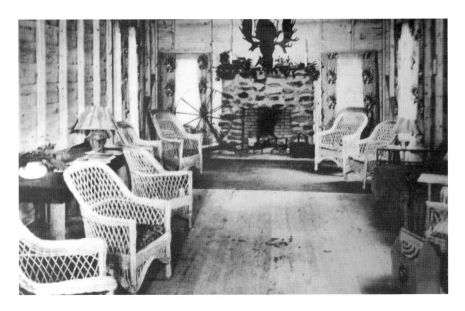

The lobby of the original Appalachian Clubhouse. *Courtesy of Great Smoky Mountains National Park.*

The Appalachian Club property consisted of three sections: Daisy Town, which was nearest the club; Society Hill, which consisted of cabins along the upper portion of Jake's Creek; and Millionaire's Row, the cabins along Little River. As the names imply, the sections were laid out according to the affluence of the owners.

While most of the summer residents were from Knoxville and content to spend the summer months in proximity to the hotel, clubhouse or cabins, there were exceptions. One such exception was a renowned artist from Nashville, Mayna Treanor Avent. A world traveler, Mayna and her husband, Frank, loved the outdoors. He was a skilled fisherman and hunter, and Mayna delighted in the beauty of the Smoky Mountains.

Although they had previously built a summer home near the Appalachian Club and spent time in the Smokies regularly, in 1918, Frank and Mayna jumped at the opportunity to buy a cabin farther up Jake's Creek from their Elkmont home. Given their mutual interests in hunting, fishing and hiking, the Avents quickly became good friends with their new mountain neighbors, such as local guides Sam Cook and Steve Ownby.

Steve Ownby and his Uncle Lem often looked after the Avent cabin while the owners were away in the winter months. Frank Avent's position as a railroad commissioner for the state of Tennessee meant that he wasn't able

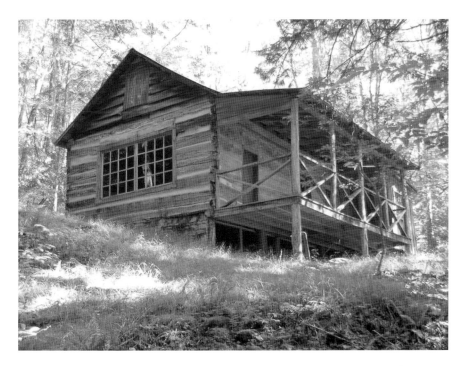

The Avent Cabin, where renowned Nashville artist Mayna Avent created many of her paintings. *Author's private collection.*

to get away to the cabin as often as he would have liked; thus Mayna would often be chauffeured to Elkmont by a handyman, and Frank would join her and their children when time permitted.

When they purchased the old rustic cabin, it already had a rich history. It was believed to be one of the oldest buildings in the Smokies, although no one can say for sure when it was constructed. Lem's oldest brother, Dave, once occupied the cabin. When his son Steve married Sam Cook's daughter Eva, the newlyweds moved in the house, which was on fifty acres of land. Steve and Eva Ownby's first two children, Iva and Albert, were born in the cabin before it was sold to the Avents. Mayna Avent spent most of her summers there until she was too old and infirm to travel the distance.

During her many summers living at Elkmont, Mayna produced several of her notable paintings, including an oil on tin titled *Indian Pinks in the Mountains*, a carved woodblock of the cabin and a gouache of Lem's sister-in-law Martha McCarter Ownby, titled *Jake's Creek, 1914*.

When it came to the creation of a national park, members of the Appalachian Club, along with various other influential individuals in

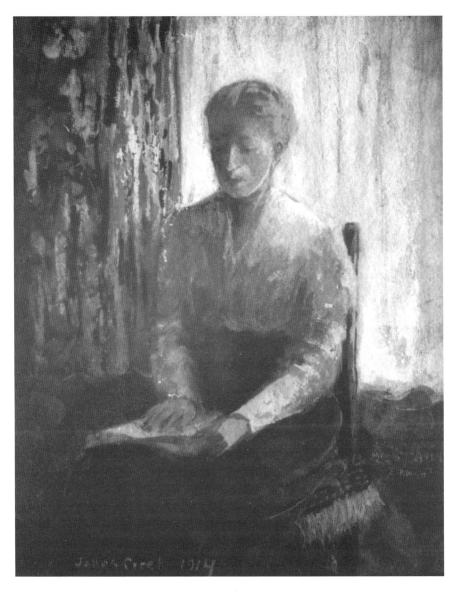

A gouache of Martha McCarter Ownby, Lem's sister-in-law, painted by Mayna Avent in 1914. *Courtesy of Winfred Ownby.*

Tennessee and North Carolina, had vastly differing views on the subject. While everyone seemed to be in agreement that the majestic mountains needed protecting, there were those who were at odds over the best approach.

Horace Kephart is often credited as a catalyst for the movement to protect the mountains with his publication of *Our Southern Highlanders: A Narrative of*

Adventure in the Southern Appalachians and a Study of Life Among the Mountaineers.
He wrote the book in 1913 after moving to the isolated mountains of western
North Carolina to escape the rigors of society.

Willis P. Davis and his wife, Ann, and Colonel David Chapman
spearheaded the idea of a national park on the Tennessee side of the
Smokies. It was Mrs. Davis who first advanced the idea of making the
Smokies into a national park after she visited national parks in the west.
Knoxville attorney James B. Wright, a longtime Appalachian Club member
and conservationist, wanted it to become a national forest.

Chapman, who did more than any other to create the Great Smoky
Mountains National Park, wanted roads and facilities for all Americans to
enjoy. These visitors also would mean money for the local economy. But
Wright wanted the area kept uncontaminated by the maddening crowds. He
said that he stood for conservation.

In its heyday, the Appalachian Club was quite impressive. There was a
boardwalk stretching for a half mile up Jake's Creek. Social gatherings were
commonplace, and on Saturday evenings, guests and members danced to a three-
piece orchestra from Knoxville. Ordinarily the lights went out at the club at 10:00
p.m., following a blinker warning fifteen minutes earlier. Those who didn't leave
quickly had to grope along on the dark boardwalk to find their cabins upstream.

Electricity was a precious commodity and was available only two hours a
day. A wooden flume provided the necessary force into a small powerhouse.
As the electricity came on daily, the women rushed to do their ironing, but
the current would get so low the irons wouldn't even heat. These were minor
technicalities, though. The people kept coming, summer after summer.
Summer season began at Elkmont on June 1 and ended on Labor Day. Yet
some of the less adventurous among the visitors didn't arrive until after July
1 in order to miss the "black gnat season."

Camaraderie developed between the summer residents and the mountain
folks. This situation came about because of their dependence on each other.
The summer residents needed domestic help for cooking, cleaning and
maintenance of their cabins. On the other hand, the mountain folks needed
the income from the jobs and from selling their farm products.

In addition to farming, Lem Ownby trapped bears, getting up to thirty
each year. He'd sell the skins for seven dollars each and sell the meat to the
hotel kitchen. He also sold trout, wild rabbits and vegetables for its dining
tables. Ice, packed in sawdust, was hauled in by train from Maryville. Because
the local farmers could not keep up with the demand, vegetables were also
brought in from Gatlinburg on wagons pulled by teams of oxen.

SPECKLED TROUT

"There's nothin' better than good ole speckled trout you catch yourself," Lem often commented. "Them so-called rainbows the government stocks in the creeks ain't near as good." He was referring to brook trout, which were commonly called speckled trout or just specs by the old-time mountain folks. However, most people know *salvelinus fontinalis* as brook trout or brookies.

They have yellow and brown spots with gold and dark olive camouflage markings, which gradually change color to white and then back to black on the leading edge of their lower fins. Unlike the rainbow trout, they spawn in the autumn, and that is when their colors are most pronounced.

The brook trout is the only trout species native to the Smoky Mountains. Beginning in 1931, nonnative rainbow and brown trout species were introduced into the park. Today, brook trout are only found in about 133 miles of the park's 2,100 miles of streams. Brook trout have lost about 75 percent of their native range in the park since the early 1900s, mostly due to logging and the introduction of nonnative rainbow trout.

Appalachian Club members frequently entertained guests while they were in residence at their cabins. Some of their visitors were nationally known figures, such as the famous attorney Clarence Darrow. Knoxville attorney Williston Cox invited Darrow to visit him at Elkmont immediately following the Scopes "Monkey" trial, in which Darrow was the defense attorney who opposed William Jennings Bryan, the leader of the prosecution.

During the night of July 26, 1925, Ralph Murphy, manager of the Central Hotel in Sevierville received a long-distance phone call from a reporter for the *Chicago Tribune*. The late-night caller informed Murphy that William Jennings Bryan had died earlier that day in Dayton, Tennessee. The reporter then asked Murphy if he was aware that Clarence Darrow was staying somewhere in Sevier County. Coincidently, Murphy was aware that Darrow was visiting Cox at Elkmont because the gentlemen had stopped by the hotel earlier that day and told him they were on their way to Elkmont.

Murphy told the reporter that Darrow was way up in the mountains and therefore unreachable by phone. The reporter was persistent. He wanted

someone to go to Elkmont and interview Darrow that night so he could have a quote for the next morning's edition. To get rid of him, Murphy told the pesky reporter to call someone in Maryville because there might be a connection from there to Elkmont. But the reporter called back shortly saying he had no success with Maryville.

The relentless reporter again asked Murphy to go to Elkmont. Murphy explained that it was a hard trip and would cost a lot of money to get someone to go all the way up there at that time of night. "I'm willing to pay fifty dollars," said the reporter. Murphy replied, "For fifty dollars I'll do it myself." Murphy did not own a car at the time, so he hired a hotel guest who frequently stayed at the hotel and transported passengers between Sevierville and Knoxville in a seven-passenger Buick.

It was after midnight by the time they reached Elkmont and awakened Cox, who was sleeping in the cabin next to the one occupied by Mr. and Mrs. Darrow. Thinking of Darrow's potential wrath, Cox decided he'd better awaken his friend rather than have Murphy become a victim of Darrow's infamous temper. Once awakened, Darrow had some uncomplimentary comments about the *Chicago Tribune* and told Murphy to tell the reporter he'd call the paper in the morning.

"If I go back and tell him that and nothing else, they won't pay me for coming all the way up here," said Murphy. Darrow then asked, "How much are they going to pay you?" "$50," replied Murphy. "The cheapskates, you should have asked [for] $500," retorted Darrow. The legendary attorney pondered a minute and then said, "I don't know, Bryan was truly a crusader. He believed every damn word he said, oh hell, tell them I'll call them in the morning." Darrow did call the newspaper the following day, but Murphy had called first with those two sentences—although somewhat edited for the sake of decency—from Clarence Darrow.

The reporter got his quote in time to meet his deadline, and Murphy received payment of fifty dollars, along with something he could brag about for the rest of his life. Naturally, the story made the rounds among the summer people, but it is unlikely that Lem ever knew of the incident involving the famous lawyer, although it all took place less than a mile from his house. Likewise, Lem probably never knew that Thomas Lanier Williams, who would grow up to change his name to Tennessee Williams and become one of the most famous playwrights of the twentieth century, spent part of the summer of 1926 at Elkmont.

Williams was fifteen when he and his family visited his uncle and aunt William and Belle Brownlow. In his autobiography, *Tennessee Williams:*

The swimming hole used by Appalachian Club members where famous playwright Tennessee Williams enjoyed swimming with his aunt during a visit in 1926. *Courtesy of Great Smoky Mountains National Park.*

Memoirs, he wrote, "That summer I learned to swim in a clear mountain stream; it was Aunt Belle who taught me, in the pool of fabulously cool, clear water formed by the dam, which offered a sparkling waterfall over bone-white rocks."

While Lem and his neighbors were friendly with the Appalachian Club members, they were not interested in the social lives of the rich folks and paid little attention to those who came and went. Therefore they remained largely unaware of visitors such as Darrow and Williams.

Regardless of the reason they owned property in Elkmont, in the late 1920s, residents had an uncertainty about the future. Even those summer residents who favored the development of a national park weren't eager to part with their beloved mountain cabins. Residents, such as Lem and his family, who had deep roots there couldn't imagine life anywhere besides Elkmont.

As it became inevitable that the national park would be established, conversation changed from whether a park would be formed to how they could manage to strike a deal with the government to remain on their property. One advantage the summer residents held over the poor

mountaineers scattered throughout the area was the fact that they could afford counsel and were well connected politically.

Even though Lem Ownby and many of his neighbors did not have the education or resources available that the summer residents did, they undoubtedly benefited from what they observed their affluent neighbors doing.

Whether anyone among them would be able to remain once the Great Smoky Mountains National Park was established was yet to be seen. One thing was obvious. Whether they all stayed, some stayed and others left or they all had to move, Elkmont was once again about to change drastically, and adjustments would have to be made.

Unlike other national parks where authorities already owned the land, money was needed to purchase the property from the big lumber companies and the owners of numerous small farmsteads, as well as the summer home owners. Tennessee and North Carolina governments, along with private donors, pledged about $4.5 million, roughly half of the $10 million needed to purchase the property and create the park.

Arno Cammerer, assistant superintendent of the National Park Service at the time, tried to find somebody who would contribute the remaining funds. Cammerer, for whom Mount Cammerer in the park is named, talked to John D. Rockefeller Jr. about the struggle to raise money in the Smokies.

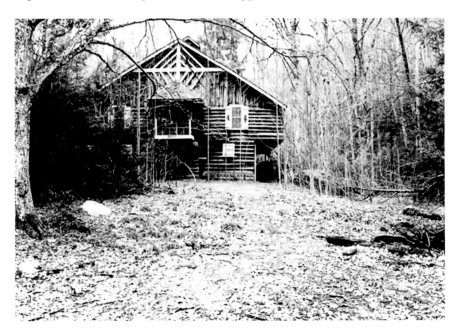

A typical Appalachian Club cabin. *Courtesy of Great Smoky Mountains National Park.*

In 1928, Rockefeller gave $5 million—in memory of his mother, Laura Spellman Rockefeller—from a foundation set up to help acquire land for national parks. His donation meant the states would now release the bond funds. Without Rockefeller's donation, the park would not have happened. He made the whole wonderful entity that is the Great Smoky Mountains National Park a reality.

On June 15, 1934, Congress authorized the establishment and full development of the Great Smoky Mountains National Park. Another ten years were required to finalize the purchase of lands and resolve other difficulties associated with creating the park.

Elkmont would never be the same.

6
A NEW LEASE ON LIFE

The price of anything is the amount of life you exchange for it.
—Henry David Thoreau

If it were within his power, Lem Ownby intended to remain on his little patch of ground. To stay there, he was even willing to relinquish ownership of his beloved land, although it might mean living out his life as an inholder within the boundaries of a national park.

Once the park service began the onerous task of acquiring property—there were over six thousand separate tracts just on the Tennessee side that had to be surveyed and purchased—those landowners who weren't inclined to sell set about gathering information and investigating every possible avenue that might allow them to hold on to their homes and land.

The transition did not occur overnight. Handed-down, embellished stories that painted park officials in a negative light were widespread at the time, especially among those who opposed the park. On the other hand, there were many who readily admitted the officials were making every effort to minimize and mediate differences in order to effect a seamless conversion.

The summer residents who were wealthy and well connected had established infrastructure far more advanced than what existed elsewhere within the proposed park boundaries. Therefore, the park service was faced with the unenviable task of hammering out an agreement with the Elkmont residents.

Incidentally, the same year the park was established, the Appalachian Club built a new clubhouse to replace the building that burned down. This was a strong indication the summer residents had every intention of staying.

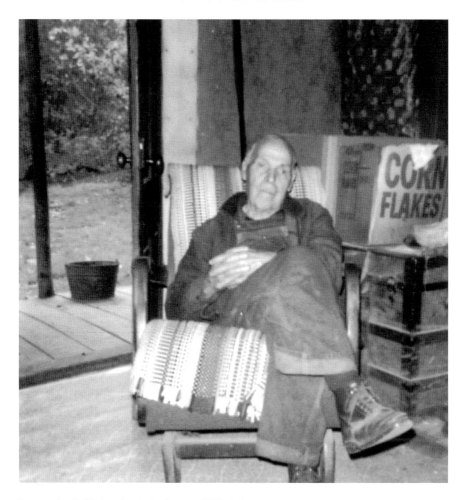

Lem resting in his favorite chair. *Courtesy of Elizabeth Ballard.*

When the ink dried on the bill, signed by President Franklin D. Roosevelt, creating the Great Smoky Mountains National Park, the Elkmont community consisted of several pioneer homesteads, Hommel Orchard, Cochran Farm, two cemeteries, Wonderland Hotel, Elkmont Tavern, a gas station/store/post office, Trentham's and Parton's stores, a camp, resort cabins, the Appalachian Club, two schools, a power plant, tennis courts, a man-made swimming hole, a ball field and a church. A sewer line connected to the Wonderland Hotel, and power lines ran to the Appalachian Club. Rounding out the amenities were water tanks, an open pit garbage dump and a cesspool.

In the meantime, the federal government allocated an additional $2 million for purchasing land and began implementing the Civilian

Conservation Corps. Known as the CCC, the corps was a public relief program for unemployed, unmarried men from eighteen to twenty-five who came from needy families.

For the newly established park, the CCC could not have been formed at a better time. The hills and hollows of east Tennessee and western North Carolina had an abundance of young, able-bodied men who met the criteria and who were grateful to work on the unskilled manual labor jobs so they would be able to send money back to their disadvantaged families.

In 1933 and 1934, around seventeen CCC camps sprang up in the new park. Elkmont Camp was the twelfth, with enrollees from New York and New Jersey. The CCC boys improved existing Elkmont roads, rebuilt two wooden bridges and constructed stone-faced culverts beneath the roads, as well as a low stone-and-wood bridge over Mids Branch. They also built the Little River stone bridge. Examples of the beautiful handiwork can be seen today all over the park.

To some residents, the improvements to access roads and the fact that the government seemed to be moving slowly in buying people out made staying in Elkmont more appealing than ever. On the other hand, some old-timers were disappointed over the loss of jobs when the lumber company ceased operations and were eager to sell out and move on.

Several members of the now sizable Ownby clan decided it would be in their best interests to move. Lem's uncle Newton Ownby and his family chose to leave, taking the money from the sale of their property to purchase land in Wear's Valley, a picturesque hamlet on the north side of Cove Mountain.

The officials' first attempts at approaching some of the hesitant mountaineers were met with unrestrained hostility. Several title abstractors came and went before John O. Morrell was appointed to the position.

Morrell was the son of a prominent Knoxville attorney. After graduating from the University of Tennessee's College of Law, he began practicing law in Sevierville, where he met his future wife, Grace Montgomery. When the TVA was acquiring property for Norris Dam and its reservoir, John took a job as title abstractor for the agency. While working on the Norris Dam project, he proved to be very efficient in dealing with reluctant landholders.

When his assignment with TVA ended, Morrell was appointed to the same position for the Great Smoky Mountains National Park. With his expertise in dealing with the landowners, his role with the park service turned out to be a pivotal one. While most of the mountain people were suspicious of outsiders, Morrell possessed a unique ability to earn their trust. Morrell

loved working in the park so much that after his appointment as title abstractor ended, he gave up his law career and became a full-time park ranger.

Morrell's daughter Mary Jenkins of Tempe, Arizona, said, "I think his greatest asset was that he knew people and knew how to approach them without getting shot. I remember riding along with him and acting as a witness. Many of the landowners were illiterate and signed the transfer deeds with an *X*."

Lem Ownby didn't deal with John Morrell because he had signed an agreement before Morrell accepted the position with the park service. Shrewd enough to realize he needed an attorney, Lem had gone to Sevierville, where he hired Judge Ambrose Paine to represent his interests. Judge Paine was a well-respected lawyer who once served as circuit judge and was henceforth called Judge Paine. Incidentally, he was also the first elected mayor of Sevierville when the county seat was finally permanently incorporated in 1901.

Lem told his lawyer that he heard other folks had worked out some kind of a deal to receive partial payment for land so they could remain there to the end of their life. It was explained to Lem that there was that possibility, but the agreement would contain some restrictions that might prove a little hard to swallow.

Undeterred by the restrictions, Lem and his unmarried brother, Burt, decided they would keep their parents' farm and divide it between themselves. After negotiations between Lem and Burt's counsel and the park service, the brothers agreed to execute what was called a life-lease agreement.

The legal description presented to the Register of Deeds included details about the 44-acre tract located in the eleventh civil district of Sevier County as follows: "30 acres good and fair cultivated land and 14 acres fair timber consisting of poplar, bass, maple; 180 bearing apple trees in good condition; dirt rock road; wire fence; farm well watered; 3 room box house; 3 other buildings in fair condition. Improvements $940. Jury of view: $3,500."

The deed, which listed A.M. Paine as attorney, was registered and reflected the final price as $4,500. The document stated: "see Bert Ownby card 22.5 and 44 acres embraced this price. Transferred to Federal Government 7/14/33."

The brothers never publicly discussed their agreement. Therefore, it is not known how they divided the $4,500. But once the deal was signed, Lem Ownby was left with approximately twenty-two acres, which included the house, outbuildings, an orchard and ample space for crops and livestock.

Lem and Mimmie did not feel as if they were isolated. As a matter of fact, some of their nearby friends and relatives were signing similar

A chicken struts around Lem Ownby's barnyard. *Courtesy of Elizabeth Ballard.*

The house Lem Ownby refused to leave when the national park was created. *Courtesy of Elizabeth Ballard.*

agreements. The summer people were working out their own agreements, and many of the amenities they had grown accustomed to having nearby were still available. Furthermore, at the age of forty-four, Lem and Mimmie could not image that either of them would be the last of the life-lease holders to pass on. They planned to simply live out their days peacefully and quietly.

Getting shot at by a backwoods landowner was nothing compared to dealing with the demands of the Elkmont summer residents. While most of the mountain families agreed on a price and moved away and a few, such as Lem, made agreements that allowed them to stay, the summer people proved more reluctant to give up their beloved mountain playground.

Jim Wright, a summer resident, was so adamant in his opposition to the creation of the national park that he no longer even wanted a summer cabin there and sold his place. But most of the Appalachian Club members were eager to work out a deal so they could continue having access to their piece of paradise.

Most of the summer owners accepted a life-lease agreement in exchange for a reduced price for their property with their cabin reverting to the park upon the death of the owner. But in less than two decades, citing the inequity of such an agreement, they were back at the table asking for the properties to be converted to twenty-year terms.

In 1972, descendants of the original summer homeowners asked to be granted another twenty-year extension. In 1976, the two social groups—Wonderland and Appalachian Clubs—united to form the Elkmont Preservation Society, hoping to hold off eviction when their long-term lease ran out. Finally in 1992, the park service stood firm and refused to extend the agreements. The owners were angry, to say the least, but were powerless at that point to reverse the decision.

THAT WHICH REMAINED

Doing what you love is the cornerstone of having abundance in your life.
—Wayne Dyer

When Lem and his brother Burt returned to Elkmont after signing the land-lease agreement, it seemed nothing much had changed. They were not the only Elkmont residents who chose to stay; many of their friends and neighbors had initially decided to stay on as well. As years passed, stories about the "exodus" from the park became embellished to the point that a stranger could easily interpret the relocation as a flight that occurred on one particular day when everyone was rushed out of their homes, lock, stock and barrel.

Winds of change were blowing through the mountains. Gradually, the newly formed park made its presence known. In time, a large campground was constructed on the site where the town of Elkmont once was situated, and the first park ranger was appointed. Fortunately, the new ranger in their midst was an easy person for the natives to adjust to. T. Lee Owenby, who was born and raised in the foothills of the Smoky Mountains, was chosen as the first park ranger. He knew most of the year-round Elkmont residents and, in fact, was distantly related to many of them, including Lem. (T. Lee Owenby added the *e* to his last name because the government spelled it that way when he began working for the CCC. Most of his relatives retained the traditional spelling, however.)

Owenby, who was often called Swede by relatives and friends after a tourist once mistook him for a man from Sweden due to his six-foot-four height and blond hair, received a position as junior patrolman with the park

service as a result of his stint with the CCC. Junior patrolman duties included fire tower watchman and manager of the Cosby Campground, located a handful of miles east of Gatlinburg. In those days, Cosby was notorious for illegal moonshine stills. Owenby often said he had an agreement with the still operators: "We don't bother them, and they don't kill us."

Owenby was a natural choice for the Elkmont position because of his almost innate ability to get along with the locals. Chances were that it would have taken a long time for someone "not from around here" to be accepted by the mountain people, who were often suspicious of outsiders.

It was in 1941 when Owenby received his appointment at Elkmont and moved his growing family into the ranger's residence. While living there, the number of his children grew to six. Owenby developed a rapport with Elkmont residents. He was well respected by the year-round folks and summer people alike. While Owenby's position as Elkmont ranger was interrupted by his service in the U.S. Navy during World War II, he nevertheless ended up serving in that position for the better part of a decade.

Both true and fictitious stories, often called "Bear Tales," have been handed down in the mountains since the first settlers arrived. In fact, Lem himself never quite lived down his unfortunate encounter with a bear. Anyone who's ever seen a mound of bear scat on a Smoky Mountain hiking trail knows it would have been quite a "large" misfortune to overcome. Much to Lem's embarrassment, the story was repeated over and over, both in and out of his presence. Lem was as amused as much as anyone in Elkmont when word got out that Ranger Owenby had his own embarrassing encounter with one of the Smokies' so-called black ambassadors.

There was one particular bear that regularly annoyed, and even scared, campers at the Elkmont Campground and people around the ranger's station. After continually reassuring alarmed campers and picking up scattered debris, Owenby was ready to put an end to the disruption. He finally set a trap and subsequently caught the culprit, which was estimated to weigh a staggering five hundred pounds. The enormous bear was kept on display on the campground for several days before Owenby painted an identifying white stripe on the bear, loaded him in a truck, drove fifteen miles to Tremont and released the animal high up in the mountains. When Owenby returned, he was greeted with all manner of hoots and hollers because the bear, sporting his distinguishing white stripe, had beaten him back to Elkmont.

Owenby's trout fishing skills have long been remembered and lauded. He was known to travel upstream directly behind another fisherman and

still catch his limit in record time. Always a strict enforcer of the rules, he never caught more than the law allowed and was always on the lookout for poachers. Because he felt it inappropriate to work on Sunday, T. Lee Owenby resigned in 1951. Lem Ownby was among many who hated to see him go.

As the years passed, others who had chosen to remain in their mountain homes decided to leave as Elkmont began to morph into more of a summer resort for the affluent than a year-round residential community. With schools closing and stores going out of business, it didn't seem like home anymore. There were also those who left because they were constantly at odds with park officials over the enforcement of what they considered overly harsh policies, particularly those regarding hunting. But one of the biggest setbacks to the old-timers was the dissolution of the Elkmont Baptist Church.

After the pastor moved out of the park, church services were no longer held in the white-frame building that had served the spiritual needs of Elkmont since its construction in 1916 during the height of the logging boom. In early 1938, a group of families living in Wear's Valley at the foot of Cove Mountain, some of whom had moved from Elkmont, felt led to establish a new Baptist church in their area. They had been holding worship services in homes until an abandoned store was converted into a crude worship space. On April 17, 1938, thirty people officially organized the new church, which they named Valley View Baptist Church.

Property for the church building was graciously donated by one of Lem's first cousins, Baus Ownby, and his wife, Mittie. The old store building was dismantled and rebuilt on the property as a temporary house of worship. Somehow, John Ownby, another of Lem's cousins, persuaded the park service officials to let the Valley View congregation have the vacant Elkmont Church. While remaining Elkmont residents, including Lem and Mimmie, were sorely disappointed to see the church torn down and moved, the folks in Wear's Valley celebrated that the same building in which many of them had worshiped before relocating would once again serve as their home church. A part of Elkmont would live on.

Work on dismantling the twenty-two-year-old structure began immediately. Plank by plank, the postcard-worthy mountain church came down. Now, the Elkmont Campground could be enlarged, yet another sign of the community's transformation. The disassembled church was loaded onto trucks and hauled to the picturesque Wear's Valley, where it was rebuilt.

The first worship service was held on July 3, 1938. Four years later, a cemetery was established behind the church. Church services were held in

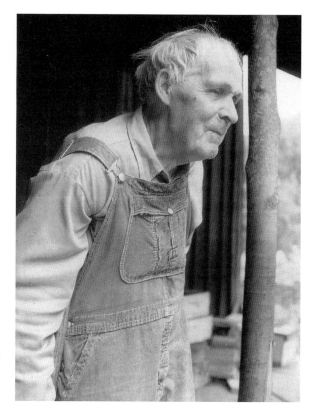

Right: It was rare to see Lem Ownby without a hat and without his staff, which offered both support for his weakening body and assistance as he moved around the farm as a blind man. *Courtesy of Elizabeth Ballard.*

Below: Lem Ownby might have had "running water," but his other facilities were outside. *Courtesy of Daniel Paulin.*

this building for over half a century before the congregation moved into a new brick building in 1995. The old church still stands, although it has been altered by renovations over the years. To honor the rich history of the old building, it was renamed Elkmont Chapel.

As fragments of his familiar existence vanished, Lem's relatives would occasionally suggest that it might be to his advantage to move out of the park. Every time the subject was mentioned, he stubbornly resisted. By the time T. Lee Owenby left Elkmont in 1951, Lem and Mimmie were sixty-two years old, and his eyesight was continuing to deteriorate more each year. While many well-meaning relatives and friends worried about them, they were hesitant to meddle in the couple's affairs. As long as Lem and Mimmie were getting by and could take care of themselves, they saw no reason to interfere.

The time eventually came, as he knew it would, when diminishing eyesight and advancing age prohibited Lem from performing some of the more rigorous farm chores he had carried out with ease in times past. Lem picked apples in his orchard until it was no longer safe for him to climb a ladder to get to them, but he continued his honey gathering and worked a small garden bed. Gone were the days of large corn and tobacco fields that he worked with mules and horses. Lem had no choice but to curtail certain dangerous and strenuous tasks that were such an integral part of farming.

The decades of the 1940s and 1950s progressed uneventfully for Lem and Mimmie. One day in late September 1951, a visitor was telling Lem all about a big event unfolding in Gatlinburg. The forty-third-annual Governors' Conference was taking place at the Greystone Hotel, and the governors from all of the forty-eight states, plus a few territorial governors, were being hauled around town in purple convertibles. Unable to mask his disdain over such opulence, Lem exclaimed, "They kin stay away from here puttin' on the dog in them big purdy purple cars." Lem never drove or owned a car in his life.

The Walker Sisters of Little Greenbrier Cove became celebrated after the *Saturday Evening Post* article told the story of self-reliant sisters living in the isolated mountains and clinging to their old-fashioned ways. At first, the resourceful sisters welcomed curious visitors, who were usually willing to buy whatever handmade products the spinsters managed to have on hand. As the number of visitors increased and the spinsters grew older and some died off, entertaining the tourists became overwhelming and physically taxing. The park service eventually posted a sign to limit visitors. When Louisa Walker passed away in 1964, it was Lem and Mimmie who carried the torch to the end as the last family living in the Great Smoky Mountains National Park on a land-lease agreement.

LINN HONEY

Beekeeper Lem Ownby's favorite variety of honey was what he called linn honey, made from basswood or linden tree blooms. Basswood honey has its own distinct flavor: a light mild honey with a slight mint taste. Basswood trees can be found in abundance in North America. They are deciduous and are nicknamed "the bee trees."

In Roman mythology, the tree was used as a symbol of love and fidelity. Due to the tree's strength and softness, Native Americans used the tree's fibrous inner bark to make rope. The tree was also important for rituals, providing the wood for creating masks.

The flowers of basswood are used to make linden tea, which was thought to have sedative properties and was sometimes used to fight colds, prior to the availability of modern treatments. Since basswood has a fine texture, straight grain and is very light, it has many modern-day commercial uses. It is commonly used in casket making, furniture, toys and other objects where a lightweight wood is beneficial. Basswood's color is a light, creamy brown, providing an aesthetically pleasing look to many people.

Burt's vision had always been more limited than Lem's. Unmarried and unable to care for himself, by the 1950s, Burt began sharing his home with Josie and Clifford Teaster, who provided a measure of assistance. Burt passed away in 1959 at age eighty-six. He lived his entire life at Elkmont. Lem's sister Lucy Cardwell died in 1966. And then there was one. Lem was the last surviving sibling of the nine children of Thomas and Sarah Ownby.

Regardless of his incapacitation, Lem never gave up his beloved avocation, beekeeping. He developed the necessary skills early in his youth and always took pride in his pure mountain honey. Once he was asked by a reporter how he managed to have such smooth skin at an age when most people his age had just the opposite. "I lay it to the honey," Lem replied unhesitatingly.

When Lem was growing up, honey was the primary sweetening agent instead of sugar. It was also used medicinally and believed to promote rapid healing as well as having other curative properties. The origins of beekeeping can be traced back to the introduction of the honeybee in America. Bees became so numerous that Native Americans called them the "white man's fly."

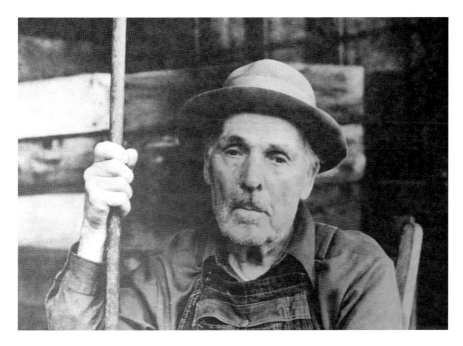

Lem Ownby sitting on his front porch. *Courtesy of Great Smoky Mountains National Park.*

Sourwood honey has long been the most popular honey produced in the Smoky Mountain region, but Lem's favorite by far was made from the nectar of linn (linden or basswood) trees. There were various ways to acquire bees. One somewhat unpleasant technique used to obtain a hive of bees common when Lem was young—and said to be virtually foolproof—was to place corn cobs and dirt in a bucket, urinate in it and then leave it for a few days. In time, the bees would be drawn to the bucket's unsavory contents. After a hive was established, honey slathered on a corncob was said to attract bees.

Finding a bee tree was, for a mountain man in the old days, like money in the bank. A bee tree was simply a tree where a swarm of bees had taken up residence. When someone located a bee tree in the forest, he made three hack marks on the tree marking it as his own and letting others know the bees had been claimed. This unwritten law was usually honored.

Lem's honey was well known and guaranteed Lem of a steady stream of visitors—and income. He took pride in his product and had no qualms about selling it for whatever the market would bear. Sometimes dishonest customers would be shocked when they tried to slip Lem a one-dollar bill instead of a five. Lem would set them straight right away. Just by touch

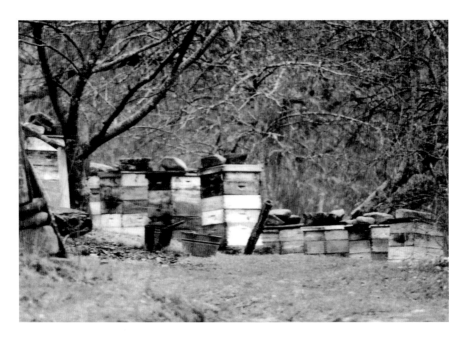

A view of Lem's beehives located in his front yard near his coal pile. *Courtesy of Elizabeth Ballard.*

it seems Lem could distinguish the denomination of the notes. He was a shrewd businessman, despite his infirmities.

One hot summer day, a couple tourists accidently came upon Lem's old board-and-batten shack. From the looks of the place, they assumed it was abandoned—until the dogs started barking. By this time, they were out of the car and had noticed the beehives. Terrified of the possibility of being swarmed by bees, the city slickers turned toward their car when they heard Lem call out, "Can I help ye?" "No sir," came the reply in a somewhat shaky voice. "We ended up in your driveway by mistake. We'll be on our way now," added the accidental visitor. "Would ye be interested [Lem pronounced it inner-rested] in a jar of good ole pure mountain honey?" Lem inquired. "Thank you, sir, but no, I really don't like honey," said the surprised visitor.

Later that day, the tourist shared his account of the unexpected visit to Lem Ownby's place to a park ranger. When the park ranger asked the man how he got out of buying some honey from the old-timer, he confessed that he hadn't. He'd ended up with three jars, which he said he had purchased at an overly inflated price.

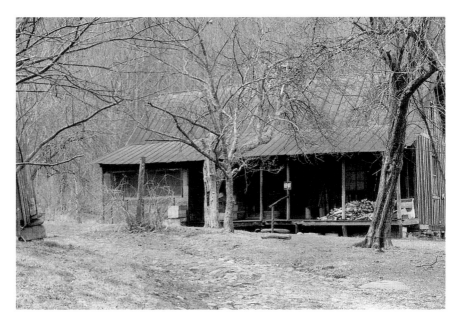

Firewood piled on Lem's front porch to use in his cookstove. *Courtesy of Great Smoky Mountains National Park.*

Except for his vision issues, Lem was blessed with reasonably good health as he approached his mid-seventies. However, Mimmie was not so fortunate and began to deteriorate physically. Lem was faced with a dilemma. He eventually realized that he could not see well enough to care for Mimmie at home. Relatives pitched in, providing transportation to doctor's appointments, but the time came when her physician suggested that she be admitted to a nursing home where she could receive round-the-clock care.

The decision to put Mimmie in a nursing home was a heartrending one, but when her situation continued to decline, Lem felt as if he had no alternative. Mimmie entered Knoxville Convalescent Home in 1966. It was a long way to Knoxville, and it goes without saying that Lem didn't drive. Relatives and friends chauffeured Lem to Knoxville about twice a week until she passed away on December 2, 1967. She was seventy-eight.

Losing his beloved Mimmie was heartbreaking to Lem, who was nearly seventy-nine and almost blind by this time, which didn't make accepting his loss any easier. In what some people considered a surprising decision, Lem chose to have Mimmie buried in the Valley View Cemetery beside the old church that was once a social and religious focal point in Elkmont. Given the fact that his parents and most of his siblings are buried in the Levi

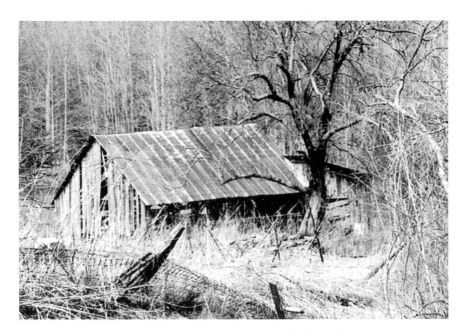

One of several outbuildings on Lem Ownby's farm. *Courtesy of Elizabeth Ballard.*

Trentham Cemetery at Elkmont, it seemed logical that he would choose to have Mimmie interred there. Mimmie had often told him that she had no desire to be buried inside the park, "where the bears can eat my bones." Following his wife's wishes, Lem laid Mimmie to rest at the Valley View Baptist Church cemetery in Wear's Valley, where her remains could rest alongside Lem's transplanted kinfolk.

8
KITH AND KIN

You have succeeded in life when all you really want is only what you really need.
—Vernon Howard

L em outlived his parents, siblings, wife and most of his extended family members and friends. With the passing of time, fewer people were left to share relaxing afternoons with Lem on his front porch. Gone were many of his contemporaries, folks he could talk with about things of the past and people and places familiar to them. Reminiscing was a favored pastime in the mountains, but many of those few who were still alive were getting too old to make the trek to Lem's. Back in the day, as the melody of Jake's Creek played in the background as it had for who knows how long, it seems there were plenty of individuals who, when an opportunity came along, were there on that front porch to share in some lively conversations.

One of the last survivors of Lem's close family circle was his brother-in-law Lee Higdon. Lee lived in the Appalachian Club's caretaker cottage with his daughter Fay and his son, J.T. The three were frequent visitors after most of the others were gone. Mountain life might have seemed boring to outsiders, but there was no shortage of topics to talk about as they passed time sitting on the porch, usually reared back on the two back legs of a ladder-back chair, with the sounds of laughter, nature and the telltale ping of chewing tobacco juice as it was spat into an old tin can. In fact, Lee Higdon's life story is an interesting aside. He could recount episodes from his past all day if he had an audience.

During the early days of logging in the Smokies, Lee Higdon had walked across the mountains from his home in Proctor, North Carolina, with the intention of staying only long enough to help the logging company he worked for back home set up camps for Little River Lumber Company. He spotted a pretty young girl named Julia Mae about two weeks later, and North Carolina was no longer his home. Julia Mae was Lem's sister. She and Lee married in 1909.

Since Lee had previous experience as a logger, he had no problem hiring on with the Little River Lumber Company. The company welcomed the mountaineers, who were so rooted in the area that they proved to be a more stable workforce than outsiders and therefore played a key role in the profitability of the company and the economy in general. When finances allowed, the young couple purchased a farm adjacent to where Julia Mae grew up, and her parents and unmarried siblings, including Lem, still lived.

When the park was established, Lee and Julia received $1,000 for this home and twenty-five acres. Contemplating a move from Elkmont, Lee bid on a farm in Gatlinburg but stubbornly refused to budge over a few dollars' difference between his offer and the owner's final asking price. Instead, Dick Whaley purchased the property, where he built the iconic Greystone Hotel. Today, Ripley's Aquarium of the Smokies sits where the Greystone once graced the quiet main street in Gatlinburg.

Instead of moving to nearby Gatlinburg, the Higdon family moved to Granite Station near Clinton, Tennessee. They quickly became homesick for the mountains—which have a way of getting into one's blood—and in 1935, the Higdons returned to Elkmont and settled right back into the same home they had vacated five years earlier. This time they were allowed to live there through a lease agreement with the park service.

Although older than most of the CCC men, Lee Higdon worked on the crew that built the road connecting Gatlinburg, Tennessee, and Cherokee, North Carolina, by way of Newfound Gap. While working on the road project one day, he stepped out of a tunnel to retrieve a tool, and seconds later, the tunnel collapsed, killing a fellow crew member.

At one time, Lee managed the Chimney Campgrounds, and at another time, he operated the commissary and post office at Elkmont. Later, Lee worked for the park service as a fire tower watchman. While stationed at a tower high up in the mountains one day, Lee spotted a fire at what appeared to him, from that distance, to be his home. He bounded down the mountains as fast as his legs would carry him, heart pounding from fear and exertion.

The Appalachian Club's caretaker's cabin where Lee Higdon and his family lived. *Author's private collection.*

He found his house totally engulfed in flames. He feared his family had perished in the fire, but relief rushed over him when he met them on the path to Lem's place. After the house burned down, Lee managed to work out a deal with the Appalachian Club in which he was given a life lease on a cabin in exchange for providing caretaker duties for them. His wife, Julia, along with Fay and J.T., pitched in to help Lee with the caretaker responsibilities, such as routine maintenance, plumbing problems, winterizing the cabins and preparing them for the owner's return in the summer.

One thing Lee took a lot of good-natured ribbing about was his driving. He was a notoriously bad driver—so bad, in fact, that his family did not allow him behind the wheel for the last fifteen years of his life. Family members often said that he had a hard time keeping a car between the ditches on a two-lane highway.

Lee Higdon lived at Elkmont until he passed away in 1969, and J.T. and Fay stayed on until the lease expired. Sadly, J.T. Higdon inherited Stargardt's disease, the same disease that his mother and uncles suffered from for most of their lives. Therefore, it fell to Fay to do all the driving. She was said to be

a sight to see, due to her short stature. She had to place a pillow on her seat in order to hold onto the steering wheel and see out the windshield.

Another interesting individual whose name came up during the front-porch gatherings was Sam Cook. A longtime friend and neighbor, Sam's daughter Eva married Lem's nephew Steve. That made him family. Like Lee Higdon, Sam Cook came to Elkmont to work as a logger. He and his wife, Minnie, stayed there and raised their family. After the Little River Lumber Company pulled out, Sam decided to earn some money as a guide. He offered his services to the Appalachian Club members who were unfamiliar with the rugged mountain terrain.

One day Sam led a group of women from the club on a hike. When the ladies returned to the clubhouse, they appeared to be upset with their guide but returned to their cabins without comment. An observer looked at Sam and asked how it went. "Not too well," answered Sam. "I pointed out some bear scat along the trail. One of the women asked me what bear scat was, and I told her. After that, they all high-tailed it back as quick as they could." Sam soon realized he was more suited to lead groups of men on hunting expeditions than "to try to please them highfalutin' women."

Levi Trentham, Lem's uncle through marriage to Litha Emmaline Ownby, a sister of Lem's father, died a few days before his eighty-fourth birthday. However, tales of his exploits were repeated years after his death. An imposing figure with a long beard, Levi was known around Elkmont as the "Prophet of the Smokies." He reputedly earned this moniker by telling of visions that later came to pass, at least according to his own speculative reasoning.

An often-repeated story about Levi is the time he and Ben Parton struck off up Jake's Creek in pursuit of a bear. Trentham and his neighbor Parton had hunted the bear around Elkmont for years. They carried heavy powder rifles and long hunting knives, for skinning. This particular time, they found a cave they thought might be the bear's den. Parton crawled in the cave to flush the bear out. Levi waited at the mouth of the cave.

Suddenly, a thunderous roar came from within the cave. Parton had found the bear, and the fight was on. Human screams were as loud as those of the beast. About half an hour later, Parton emerged. Scratched and bleeding, he inched his way to daylight, dragging his quarry behind him. Paying little attention to Parton's ripped flesh and tattered clothing, Levi stroked his beard in contemplation and casually asked, "You-a-gettin' my bear?" Parton screamed his answer, "Your bear, hell! Go in and get your own damn bear!"

Bill Hooks, in his book *Whistle over the Mountain*, tells that Levi Trentham couldn't read or write yet ran a grocery store. Levi's filing system consisted

of nails hammered into the walls of his store; each nail "belonged" to a certain customer. When someone bought an item on credit, Levi would draw a picture of the item and put it on the customer's nail. One day after a man had settled up his bill, he came back and told Levi that Levi had cheated him and, furthermore, that he had cheated Levi. When Levi asked how that happened, the customer said, "You charged me for something I didn't get, and you gave me something I didn't pay for." Uncle Levi said, "What be it?" The customer said, "Well, you charged me for a wheel of cheese, and I ain't bought no wheel of cheese." Levi said, "Well, what did you buy, then?" "I bought a grindstone!" Levi told him that he'd just forgotten to draw the hole in the picture and that's why he had mistaken cheese for a grindstone.

Lem and Mimmie's porch was a gathering place any time the weather permitted, but those who happened to gather there in early June were likely unwitting witnesses to a rare phenomenon. Commonly called lightning bugs, synchronous fireflies are a species known to scientists as *Photinus carolinus*, and one of their most spectacular light displays takes place each June at Elkmont. Unlike most fireflies, these bugs light up in unison.

The synchronized display is actually a mating ritual in which the male attracts the female by flashing his yellow-green "lantern" twice per second

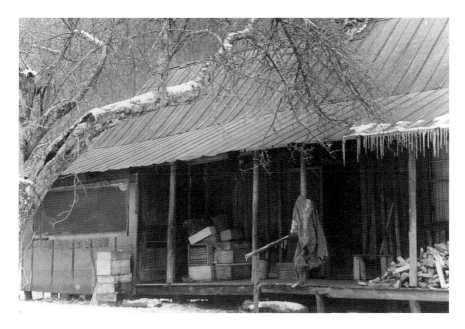

Winters were cold in the Smokies. The Ownby's gutterless eaves were often wreathed in icicles over a foot long. *Courtesy of Great Smoky Mountains National Park.*

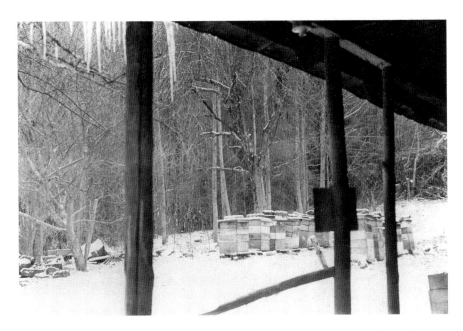

A view of Lem's beehives, covered with snow, from his front porch. *Courtesy of Great Smoky Mountains National Park.*

in timed bursts of four to eight flashes. Today, thousands gather to see the impressive display by the only species in the United States that is capable of synchronizing its lights. However, the folks who were born and raised there probably never realized they were unique. They were used to the stunning display; it was just the way things were.

Lem enjoyed entertaining old friends who once lived in Elkmont. One such visitor, who lived almost as long as Lem, was a gentleman named Jim Shelton. Three years older than Lem, Jim also grew up in the Smoky Mountains. While an infant, he was stricken with infantile paralysis, which caused him to lose sight in one eye. As a teenager, Jim worked for Granville Calhoun herding cattle on grassy balds such as Spence Field and Russell Field above Cade's Cove. Along with Calhoun's brother-in-law, Jim Russell, they herded around fifty head of cattle up the mountain in early spring and back down in the fall. To prevent the livestock from eating poisonous plants along the way, the teenagers muzzled the cattle using wire. Throughout the summer, they hiked once a week up to the balds to check on the herd, carrying a bag of salt to feed them. Once Jim considered himself a grown man, he began farm work for John N. Walker of Little Greenbrier Cove for ten dollars per week plus room and board.

Jim soon met Walker's daughter Caroline, and they fell in love, married and started a family. Out of the seven Walker sisters, only Caroline married. The others remained spinsters and lived out their lives in their log cabin inside the park. Jim often joked that the other sisters remained single because he was the only man who had the courage to "bust up the family."

Before he and Caroline married, Jim became interested in photography. His equipment was a bulky bellows camera with a rectilinear lens. The camera made negatives on glass plates five by eleven inches in size. He frequently boasted that his camera was one of the best ever made, with the best set of shutters on it that squeezed the bulb to make an exposure and three track bellows that focused on whatever he wanted to shoot.

Carrying his heavy equipment, Jim climbed mountains and leapt from boulder to boulder to cross creeks in order to record a pictorial history of the Smoky Mountains. While the Little River Lumber Company was in its heyday, Jim lived near Elkmont and sometimes worked for the company. That is when he and Lem became acquainted.

Scenes of the camp, log skids and other machinery dominated Jim's considerable collection of photographs. He developed his pictures in a crude darkroom he built that included a spring-fed trough he used to process his images. Although he never achieved as much recognition as Jim Thompson and Albert "Dutch" Roth, his photographs have been widely used to chronicle events in the mountains before the park was established.

One Sunday afternoon, Jim was out with his family following along the main railroad track down Little River Gorge where he decided he would get a picture of the swinging railroad bridge that crossed Little River at the mouth of Meigs Creek. This railroad bridge was built somewhat on the order of a footbridge. It had very little visible means of support. What it did have in the way of support came from the steel cables suspended across the river under the ties that held the rails. They were guy cables to keep the bridge from swinging side to side.

The engine that operated on the short stretch of railroad above this was not a locomotive. It was a flatcar with an engine mounted on it. The engine did not power the wheels, but rather it powered a big drum or winch. To get the rig up and across the incline bridge from the main railroad, the engineer would allow the drum to unwind while a crew of men took hold of the end of a big steel rope and dragged it up the bridge to a large stump on top of the hill. There, they would anchor the cable to the stump, and then the engineer would start the drum rolling. As the cable wound around the drum, it would pull the cars across the bridge and up the incline toward the

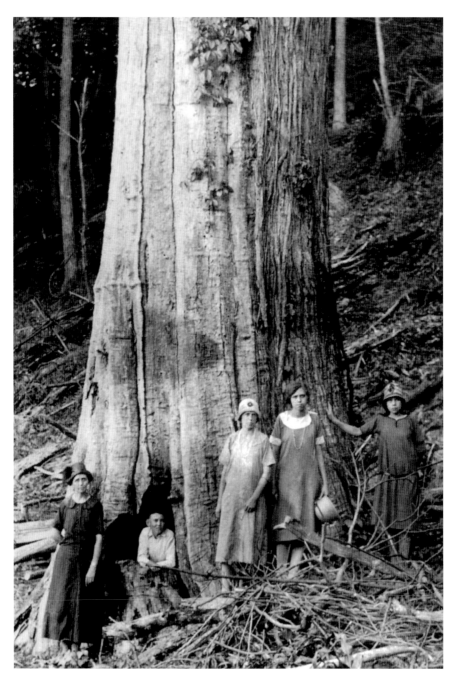

Jim Shelton captured the biggest known chestnut tree in the Smokies. It stood below Tremont Falls, where the timber cutters rejected it because it was hollow. Wife Caroline is at left. Son John looks out from the hollow; others are daughters Leona, Effie and Hazel. *Courtesy of Great Smoky Mountains National Park.*

ramp. The image he captured that day has become one of the legendary photographs of the logging industry in the Smoky Mountains.

On another occasion, Jim seized a moment in time in an iconic image of his family posing beside an ancient American chestnut tree (*Castanea denta*) before the species was devastated by a pathogenic fungus. When the Little River Lumber Company later made a notch in the tree for cutting, it was found to be hollow. Jim cut down the tree, rolled it down the bank and used it to retain dirt fill when the railroad was built above Tremont. Jim later recalled, "I would go out over the country and take a big camera on my back making pictures and Eastman Kodak was making Kodaks. They filled Sears and Roebuck stores full of them and put me out of business."

As the years rolled by, fewer of the people from the old days were left who remembered the time before the park service came in. But Lem was not completely without company as family members of a younger generation continued to visit, as did strangers who took notice of his old shack and took the time to stop in and sit a spell.

UNSOLICITED FAME

Nearly all the best things that came in my life have been unexpected,
unplanned by me.
—*Carl Howard*

Lem Ownby learned early on in his life that material things were of little importance. He recognized that a man's worth wasn't measured by his wealth, station in life or how many bears he could kill in a year, for that matter, but by his character, his devotion to family and his love of home and community. He wasn't impressed by class or status, but neither was he offended by it. He would just as quickly invite the lowliest mountaineer to visit on his front porch as he would the president of the United States had that opportunity ever presented itself—which it did not. Lem did, however, find two Supreme Court justices knocking at his front door one day.

In 1976, the U.S. Circuit Court of Appeals was having its annual conference in Gatlinburg. Justices Potter Stewart and Harry Blackmun were honored guests. On an afternoon when no conference activities were scheduled, prominent Knoxville attorney Foster Arnett, who owned one of the Appalachian Club cabins, invited the two justices, Mrs. Stewart and Knoxville lawyer McAfee Lee and his wife to relax at the Arnett cabin. Arnett's invitations were accepted, and everyone seemed to enjoy each other's company and the natural beauty of the area.

After his guests were refreshed, Arnett told them about Lem Ownby and asked whether they'd like to go up Jake's Creek to meet the old mountain man. They thought it was a splendid idea.

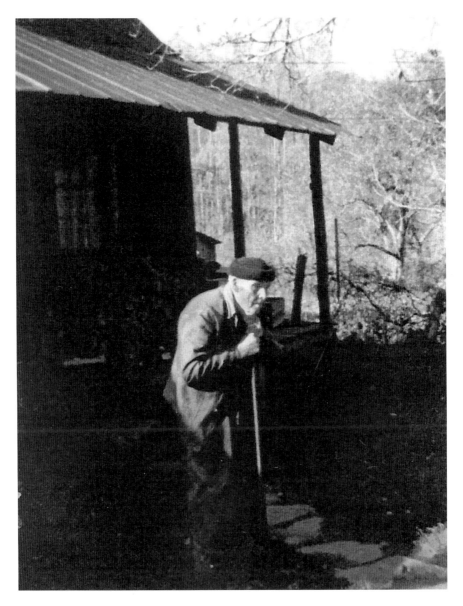

Lem Ownby taking a walk in his front yard. *Courtesy of Great Smoky Mountains National Park.*

When they arrived at Lem's house, Arnett and his guests walked through the yard with Arnett pointing out the numerous beehives, various native plants and flowers and Jake's Creek splashing nearby. They walked up on the porch and Arnett knocked. "Who's there?" Lem called out. Arnett answered,

"It's me, Uncle Lem, Foster Arnett, and I have some special guests I want you to meet."

"Well who are they, and what do they want?" was Lem's reply, which might have been interpreted as either witty or terse. Arnett replied, "I want you to meet the Honorable Justice Potter Stewart and the Honorable Justice Harry Blackmun, Uncle Lem, they are on the United States Supreme Court!" Lem then asked, "Them men from Washington?" Arnett answered, "Yes, Uncle Lem, and they are very important people who want to meet you."

"Don't care. Don't want to see anybody from Washington. Tell 'em to go away." Arnett was mortified. As he stood there pleading for an audience with a simple but legendary mountain man, the two justices were doubled over in laughter. Dejected, Arnett came off the porch, embarrassed by his rebuff, apologizing and begging his guests for forgiveness.

"Foster, this is the best thing that has ever happened to us!" one of the justices said. "People don't tell us no. This is wonderful," they agreed, still chuckling. From that day forward, Arnett's Christmas cards from the Blackmun and Stewart families were always signed, "Give our best to Uncle Lem." Every later visit Arnett made to Lem's meant he had to relive that awkward experience. Lem would always ask Arnett, "You got them fellers from Washington with you?"

The story of Uncle Lem Ownby and the two Supreme Court justices quickly became legendary. There are few people who ever knew anything about Lem who haven't heard about it. However, refusing to receive visitors was uncharacteristic of Lem. Normally, he was glad to see everyone who showed up at his door.

Carson Brewer, a columnist for the *Knoxville News Sentinel*

Lem Ownby's house as it appeared from the end of the road. *Courtesy of Elizabeth Ballard.*

who wrote often about the people and places in the Smoky Mountains, introduced Lem Ownby to a number of people who lived in the immediate area. Surprisingly, there were a lot of people who were unaware of the living legend. Brewer wrote of his first encounter:

> *I never knew Lem existed until one bright morning in the late 1970s. I was hiking from the Sinks, on Little River, to Elkmont, where my wife, Miss Alberta, was to pick me up. I was within a few yards of Jake's Creek Trail when I saw a cabin in a clearing downhill to my left.*
>
> *Chickens scattered from my path as I detoured toward the saw mill dwelling in the clearing. Two friendly dogs met me. Bees buzzed around more than 100 hives.*
>
> *And there was Lem, a short, slow-moving man wearing bib overalls. I learned later that he moved slowly and carefully because he was nearly blind.*
>
> *Lem was not sophisticated. Only once had he been out of Tennessee. He walked over the mountain "to buy a dog from a feller" who lived on Tow String Creek in North Carolina but still in the Smokies. Knoxville was the farthest place from the Smokies he ever went and usually went there only when Mimmie had to go to the hospital.*
>
> *"I never took a dose of doctor medicine in my life till I was fifty-five years old." He said he had eaten honey "might nigh every day" for more than fifty years. He spent five weeks and one day in St. Mary's Medical Center at Knoxville when he had pneumonia in 1970. He didn't like it, couldn't stand the water. Somebody finally had to bring him water from the mountain spring that's piped constantly to his back porch.*
>
> *Lem also didn't like the rainbow trout stocked in the Great Smokies streams in later years. He preferred speckles His favorite honey was linn.*

It was around this same time that Lem's grandnephew Roy and his wife, Jean, were given permission to move a house trailer onto Lem's property so they could live there and watch after him. By living nearby, they could keep an eye on him without invading his space or making the fiercely independent Lem feel like he was a burden. Jean would prepare hot meals for Lem while Roy could take care of the upkeep, what little there was at this time.

The park service made other allowances to accommodate Lem as he grew older. They gave permission for him to install electricity and a telephone. He liked to boast that for sixty years he had **running water that still worked** just fine for him. He loved to tell anyone who'd **listen that his spring water** had six different minerals and that people came **from miles around** to get it.

Hikers frequently walked by Lem Ownby's home to reach Jake's Creek trailhead. *Author's private collection.*

Furthermore, his coal-burning stove, a Warm Morning model 523, kept him nice and warm. With electric lights, a telephone and kin living right outside his back door, Lem was comfortable and felt secure in his situation.

Lem had acquired a sort of mystique over the years. These days, it might be called star quality. One thing that added to that fascination was a painting of him by Terry Chandler, a Knoxville artist. The painting was of Lem standing in front of his house leaning on his staff with his beehives in the background. Completed in 1981, the limited edition of five hundred quickly sold out.

Titled "Uncle Lem," it was the first color print published by Chandler and was done as a tribute to the people who had lived in the Smokies before the creation of the national park. Chandler felt, as did many others, that Lem was the epitome of a Smoky Mountain pioneer. Though the painting showed Lem in a diminished state, it still somehow managed to convey the qualities, such as strength, integrity and kindheartedness, that seemed inherent in most pioneers, not just Lem.

Once Brewer wrote about Lem in his column and Chandler released the print, Lem Ownby became even more widely known. Reporters from neighboring towns such as Sevierville and Maryville began showing up at his door hoping to get a story. People came from Atlanta, Nashville and other

towns around the southeastern United States. Lem wondered what all the fuss was about.

Practically everyone who came managed to hear a tale that had not been reported before, but there was one story that has been retold more times than the one about the Supreme Court justices. It was about the eight-day clock on Lem's fireplace mantle, the same one that had belonged to Lem's maternal grandfather, David Corn Watson.

The clock was purchased sometime before the Civil War. As the story goes, Lem's mother always knelt and prayed in front of this very clock. Varying accounts exist about whom Lem's mother was praying for in this particular story.

Some versions have quoted Lem as saying his mother was praying for her brothers at the exact moment they came home to Jake's Creek after serving in the Union army. Every one of them supposedly returned on the same day. However, Sarah Ownby's brothers would not have been old enough to fight in the Civil War.

However, her father, David Corn Watson, did serve in the Ninth Regiment, Tennessee Cavalry, and at least four of his brothers—Samuel, George, John and Henry—served in the Union army. When the war began, Sarah would have been ten years old, so it is possible that she was praying for her father and uncles. Although the Watson brothers returned home safely, it is unlikely they all arrived on the same Sunday morning. The story simply became revised in the retelling.

For decades, the old clock remained on Lem's mantle, ticking away the seconds of his life. It was one of his most prized possessions. It was no doubt a reminder of his mother, whom he dearly loved. He once told a reporter she was the best woman he ever knew. He said she weaved until it got pitch dark when she was making their clothes. "There was never a better woman that walked this earth," he said.

Published in the *Star* on April 17, 1982, an article written by Judy Galyon mentioned that Lem told her he had not voted in thirty-five years. He did make an erroneous prediction as to who would win the current race for county sheriff, though. Lem told Galyon that the last time he'd left his house was several months earlier, when he'd gone to Pigeon Forge to have his teeth pulled by Dr. Granville Shields.

He also told the reporter that his nephew Roy had been over helping him get his garden in shape so they'd have some good vegetables. Galyon wrote, "Until Uncle Lem became totally blind two years ago, he kept busy tending his modest garden, as well as raising his bees, and cutting

Once owned by Lem's maternal grandfather, David Watson, the old clock on the mantle was purchased sometime before the Civil War and always held a prominent place in the Ownby house. *Courtesy of Great Smoky Mountains National Park.*

firewood. Lem became known over the world for his special crop of wild mountain honey. He still gets letters from people in Canada and Europe, telling how they would like to try another jar of Lem's honey…Lem's once vast bee colony had dwindled from 125 hives to less than 30. And Lem wasn't sure how many bees will be on hand. 'I'll have some honey but nothing like before.'"

When he was eighty-five, Lem told Jim Dumas, a reporter for the *Star*, "We're just a-goin' this way one time, so we got to make the best of it while we can."

He added, "It's been a pretty fair life. I wouldn't live in town if I had too. Why, I wouldn't be able to sleep because of that entire racket." Lem said that he had lived the last six years (this was in 1975) at his cabin by himself since his wife died. Asked how he enjoyed living alone, he replied, "Well, it beats nothin'."

Lem said tourists sure could ask some crazy questions. He said he got a good laugh when a woman came by and asked, "How in the world do you get those bees to put honey in jars that way?"

"I used to plow with oxen and horses all over the hills. I always did pretty well with mountain life, but others would have had a hard time trying to make a living in my position. But I was never on relief. I don't have anything against relief for folks who need it, but I never thought I needed it and I sure wouldn't have taken it," he added. Asked if he had ever partaken of moonshine, Lem replied, "I never bought but one half-gallon of whiskey in my life. I ordered it from a peddler in Knoxville who claimed it was good, but I wouldn't have known good whiskey from bad. I just never fooled with it."

Lem enjoyed sharing stories of home remedies used by mountain folk. "Those were the days when old women knew how to get rid of worrisome warts without having to go to the doctor, which was good since there was a lot more warts than doctors back in those hard-rock mountains. Just steal a dishrag, then rub it over the warts, hide it under a rock and never go back. When the dishrag rots, the warts will be gone," he said

He also liked to tell of strong, self-reliant individuals who he called stubborn. He remembered Ephraim Ogle and John Hampton going up the mountain together to bring down Ogle's mule for plowing. "He's stubborn and wild," Ogle said. "There can't nobody ride him." John Hampton snorted. He gritted his teeth and rubbed his hands on the back of his overalls, he spit once and then twice. "There ain't ever been a mule I can't ride," he snapped.

John Hampton mounted. The mule ambled slowly, even leisurely, down the dirt road. John smiled. He'd show Ephraim. Coming upon a mud hole, the mule balked. He laid his ears back, stopped and refused to take another step. John Hampton yelled, and then he pleaded. Finally, he kicked the mule in the ribs. A moment later, John was pulling himself, head first, out of the mud hole. Ephraim Ogle marched over and said loudly, 'He threw you, didn't he, John?"

Lem Ownby might have refused to talk to two Supreme Court justices, but when the governor of Tennessee showed up at Lem's door, he was warmly received. In 1983, Peter Jenkins, author of *Walk Across America*, which chronicled a walk he made with only his beloved dog for company from New York to New Orleans, asked Governor Lamar Alexander to join him on a hike in the Smokies.

Jenkins suggested it would be fun to find out how the original pioneers made their way through those narrow passes and impregnable forests and wanted to retrace some of their routes. They began at Jake's Creek Trail. Their plan was to hike all day Friday and Saturday and half the day on Sunday to make it to Cade's Cove. They used packhorses and hired Delmar Caylor and Toy Henry Jr. to assist them in cooking and tending to the horses. Dwight McCarter was their guide.

On the morning they met at Jake's Creek trailhead, Delmar told them that he'd like to introduce them to an extraordinary man. "His name is Uncle Lem Ownby, and he is almost ninety-five years old. When the government was buying up land for the park, many people didn't mind selling. Much of the land was in large tracts owned by lumber companies, but there were some settlers who didn't want to leave, and wouldn't sell. Lem is the

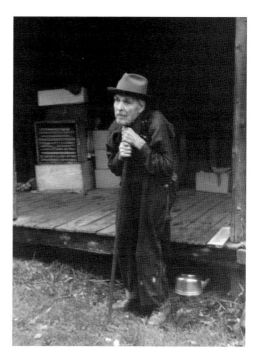

Top: Lem Ownby standing in front of his house. *Courtesy of Great Smoky Mountains National Park.*

Right: As Lem grew older, his farmstead became overgrown because he was no longer able to work. *Courtesy of Elizabeth Ballard.*

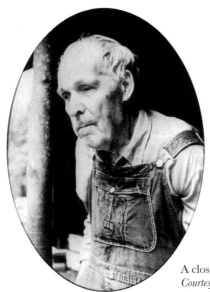

A close-up of Lem Ownby toward the end of his life. *Courtesy of Theresa Williams.*

only one left. He lives in a weathered cabin, surrounded by many beehives," explained Delmar.

Once Governor Alexander, Peter Jenkins and their entourage were invited in, Jenkins started the conversation by asking Lem why he didn't sell the place when everyone else did. "Because I was born here," Lem said as he spit into a can. "I've been chewin' since I was fifteen. I chew Blood Hound," he added before going into a story about a picture of his Grandfather Watson.

The governor was sitting across the room on the old man's bed and decided to join the conversation. "We haven't had many governors from East Tennessee before," Governor Alexander said. "Yeah, and we hadn't had many that didn't steal, either," Lem said. Lem couldn't see but he surely sensed what everyone was thinking. He paused and then said, "I ain't heard nothin' on you. Yit." Everyone laughed.

"Did you know that a lot of them people that sold their places here in the mountains for this here park died of homesickness?" Lem said. Later, when Jenkins wrote about the experience, he noted, "He never did answer me about why he didn't leave but then again he did. He's lived almost a century. And when he dies someday, it won't be of homesickness. These mountains and hollows and woods and creeks grab hold of a person and sometimes won't let go. You've got to fight hard to make them home, but maybe that fighting makes them harder to give up."

10
THE END OF AN ERA

In the end, it's not the years in your life that count, it's the life in your years.
—Abraham Lincoln

Lem's life wound down in unhurried grace. Year by year, his activities had to be curbed. His circle progressively shrank. Slowly but surely, the wilderness encroached on his land until there was barely an acre that remained cleared. Young poplars grew where Lem's cattle and horses once grazed; he was no longer able to care for livestock. Nor did he have a dog to bark at bears or timber rattlers or intruders. More and more, Lem sat and listened to the tick of the clock, as he had most of his life.

Throughout the autumn of 1983, Lem would often say to everyone he encountered, friend or stranger, "If I live 'til the twenty-fourth day of February, I'll be ninety-five years old." He had been using similar terminology prior to his last several birthdays, but each year, the statement was repeated more often. In fact, he seemed resolved that his days left on earth were few. He made it through another season of brilliant autumn colors, another Thanksgiving and the fifteenth anniversary of Mimmie's death on December 2, 1983. Christmas came and went, and the first measurable snow of the winter fell a few days later.

On Wednesday morning, December 28, 1983, Lem slipped and fell as he stepped out his front door onto the porch. When his nephew Roy discovered Lem lying helpless in the cold, the paramedics were summoned, and he was taken to Fort Sanders Hospital in Knoxville. He suffered broken ribs and soon developed pneumonia. But his condition began to slowly improve, and

it appeared he would get to return home. In fact, his doctor was about to release him after he had spent three weeks in the hospital. By this time, his doctor felt he had recovered sufficiently enough to go back home.

On Thursday, January 12, however, Lem suffered a stroke. He never recovered. On Monday morning, January 16, 1984, Lemuel Stuart Ownby breathed his last labored breath. It had been almost ninety-five years since the day the old granny woman pronounced him dead. But this time, he was gone for good.

A few years earlier, Lem told Carson Brewer that he "had his rocks bought" for his grave for when he'd be "going to a better place."

Lem would have been amazed at the publicity surrounding his passing. Local television stations reported that "a legend has died" and "the End of Era" had come as the news of his passing spread.

Carson Brewer, who wrote several articles about Lem after his first encounter with the old mountaineer in the late 1970s, wrote a moving tribute, which was published in the *Knoxville News Sentinel* the following day. "The waters of Jake's Creek still sing their music. But for the first time in nearly 95 years, Lem Ownby is not listening," he said.

"Uncle Lem was sort of a monument," said Bill Hooks, former park service interpreter. "He was the epitome of a true mountain man, the last of a breed. Uncle Lem was our last tie to a way of life in our mountains before the coming of the park."

There are few Tennesseans who will have lived the kind of life, occupied such a venerable position in the state's history or be admired for their God-fearing, hardworking and indomitable lifestyles to such an extent that the highest official in the state, the governor, will pay homage to their existence when their time on Earth is no more. Governor Lamar Alexander released the following statement:

It's hard to talk about Mr. Lem Ownby in a couple of sentences. Everyone who loves the Great Smoky Mountains should have had a chance to meet him. I almost missed my chance, but I saw him over Thanksgiving when Honey and I started a forty-mile walk from his house through the park with Peter and Barbara Jenkins. He told me that he would be 95 if he lived until February 24. In a way it is both ironic and appropriate that he died the year of the park's 50th anniversary. He was older than I am now when it was created. And he simply never left. He was an independent mountain man. His seven uncles were Union soldiers, and he was a link with what makes East Tennessee special. While we were visiting he told me that all

his uncles came home to Jake's Creek from the war on the same Sunday morning, while his mother was in the kitchen corner praying for their safe return. I guess I will never forget what he had to say about Governors. He said that most of them had stolen something, but he hadn't heard anything on me yet. I am glad to have had the chance to talk with him and to learn a little bit from him.

Interestingly, the story of the old clock in Governor Alexander's remarks was no doubt the version he'd been told, but was not entirely accurate. His entire statement did, however, manage to capture the essence of Lem's personality. Governor Alexander had sat on the bed in Lem's modest house and respectfully listened while the old mountaineer expressed his views on politicians.

Newspapers around the country picked up the story over the wire services. Winfred Ownby was working on his job, directing a cherry picker at a nuclear power plant construction site in New Jersey, when a fellow worker came up and asked him if he had ever heard of Lem Ownby of the Smoky Mountains. Winfred told the man that Lem was his great-uncle, and the man then told Winfred that he had just read in the *Philadelphia Enquirer* that Lem had died. That is how Winfred first received the news that his Uncle Lem had passed away.

On Tuesday evening, January 17, a large crowd of people gathered at Atchley's Funeral Home in Sevierville to pay their last respects to Lem Ownby. The mourners included extended family, national park officials and loyal customers who had purchased his pure mountain honey. For a couple hours, they remembered the old mountain man by repeating stories and praising his virtues. A simple funeral service was held at 8:00 p.m. in the funeral home chapel. Reverend Roy Gose, pastor of Valley View Baptist Church, officiated.

At 1:00 p.m. the following afternoon, a small crowd was present for a short graveside service at Valley View Cemetery before Lem Ownby was laid to rest beside Mimmie. Their graves are located directly behind the old church that was moved there from Elkmont.

Given his modest lifestyle, most people assumed Lem Ownby died almost penniless. They were further surprised to learn that he left a will. His will, which was the object of some controversy, read as follows:

I, Lemuel Stuart Ownby, after debts, funeral expenses and necessary taxes have been paid Will, Devise and Bequeath all the rest and residue of my estate of whatever kind and character and whatever situated to the

Mimmie didn't want to be buried "where the bears could eat her bones," so Lem had her interred in Valley View Cemetery in Wear's Valley. *Courtesy of Richard Atchley Jr.*

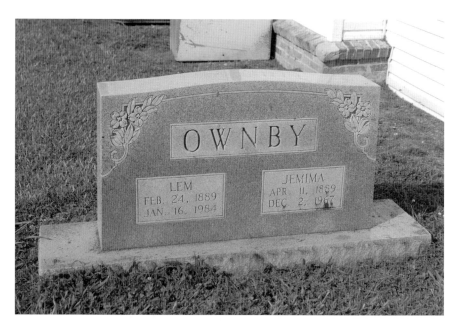

Lem chose to be buried alongside Mimmie instead of in his beloved Elkmont. The church was the original Elkmont Baptist Church that was dismantled and rebuilt in Wear's Valley in 1938. *Courtesy of Richard Atchley Jr.*

Tennessee Baptist Foundation to be held in trust forever. Because of my love for the Lord and my interest in children, I direct that income from this trust is to be for the care of children in the Tennessee Baptist Children's home. This trust is to be entered on record of the Tennessee Baptist Foundation as the Lemuel Ownby Memorial Trust and it's to remain for all to come.

Lem's trust at the time of his death was valued at $54,000. Bo Childs, president of the Tennessee Baptist Foundation, told Carson Brewer in 2001 that dividends and interest from the trust amounted to about $3,000 each year. It is remarkable that Lem Ownby accumulated $54,000. Toward the end of his life, he sold honey for $3.50 a jar. That's a lot of honey.

After Lem was gone, Roy and Jean had to move out of the park. Many people hoped that Lem's humble cabin would be maintained by the park service and open to the public like the old pioneer log cabins in Cades Cove. For several months, a debate over whether to tear it down or salvage the old shack for posterity ensued. Finally, the decision was made that because the structure was not a log cabin and was poorly constructed, it would be razed. Despite some vocal opposition, the park service proceeded to tear the old house down, along with all of the outbuildings.

For a short while, a modest sign indicated the location of Lem's place. Painted dark brown with white lettering, the sign read: "Lem Ownby Homesite: This site was Uncle Lem's homeplace for 95 years. It was acquired to be part of the Great Smoky Mountains National Park in 1933, but Lem chose to continue living here. He was the last lifetime leaseholder when he died in 1984."

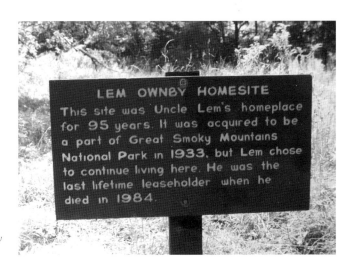

After Lem Ownby's home was demolished, a sign was erected on the site. The sign is no longer there. *Courtesy of Elizabeth Ballard.*

A picture taken during the demolition of Lem Ownby's house. *Courtesy of Dan Paulin.*

The Lem Ownby home site as it appears almost three decades after he died. *Courtesy of Richard Atchley Jr.*

For some reason, the sign did not stay up very long. Today, the only indications of the farmstead are a few perennials that continue to bloom each year and a few apple trees, ghosts of Lem's orchard. It was a decade after Lem died before the last of the summer people were forced to leave Elkmont.

When the story of Lem Ownby's passing was published in newspapers throughout the country, many of the accounts stated that he was a recluse. The *(Muncie, Indiana) Star* went so far as to call him a hermit. Although a reasonable assumption about a man who lived within the boundaries of a national park, it couldn't be farther from the truth. Lem never intended to shut out society. He was close to his family, and he loved to receive visitors.

He once described some of his mountain acquaintances as being stubborn. The description fit Lem as well. He chose to stay put, and no argument would ever convince him to move. In retrospect, if he had chosen to sell out and relocate when the park was established, it's likely that when he died, few outside his immediate family would have noticed, and certainly no stories would be written about him today.

The waters of Jake's Creek still flow, the fireflies continue to put on their synchronized display each June and hikers pass the site of the old farmstead frequently. Gone is the old house, the smell of smoke from the chimney and the buzzing of thousands of bees. But missed most of all is the old blind man dressed in bibbed overalls and leaning on his cane as he calls out from his front porch, "Kin I inner rest ye in some good ole pure mountain honey?"

EPILOGUE

There were those who argued that Lem Ownby was not the last resident of the national park. The reasoning for this contention lies with Hugh Myers, Kermit Caughron and his wife, Lois, who were still residing in Cades Cove at the time of Lem's passing. But Lem was the last to live there as a leaseholder. The Caughrons and Myers were living there on an agricultural permit, as were a few families at Oconaluftee. In 1999, Kermit Caughron, who was also an avid beekeeper, passed away at age eighty-six. His wife, Lois, moved out after he died.

Almost a decade after Lem Ownby passed, leases on the Appalachian Club cabins expired. The owners did not give up without a fight and hoped to receive another extension that would allow them access to their cabins well into the twenty-first century. However, this time, the park service stood firm, and cabin owners were forced to vacate the summer homes that, in some cases, had been used by several generations of the same family.

The lease on the Wonderland Hotel expired as well. Built in 1911, the historic hotel's last day of operation was November 15, 1992. Aware the final days of its operation were imminent, my family and I were guests at the Wonderland Hotel for a weekend in September 1992. The visit was bittersweet, knowing it would be the last opportunity we would ever have to stay there.

The floors sagged, and the walls were so thin we could talk to each other through them. But the crackling fire in the lobby fireplace and the cool mountain air that teased our faces as we took in the view from the front porch rocking chairs will never be forgotten.

During the weekend visit, we decided to walk up to the Lem Ownby place. My wife, Michelle, had heard me talk about Lem Ownby and loved the print of him by Terry Chandler that was hanging on our dining room wall. However, she had never had an opportunity to visit Elkmont to see where Lem once lived.

Ruth Headrick Tipton, a former employee of the hotel who was seventy-five years old at the time, accompanied us. She offered delightful stories of people who once lived at Elkmont and pointed out various places of interest.

When we arrived at Uncle Lem's, I was saddened to see that there was only a simple little sign marking the Lem Ownby home place. I was not aware his house had been demolished soon after his passing. Disappointed, we returned to the Wonderland Hotel. I couldn't get Lem out of my mind despite the wonderful dinner that included whole dressed Smoky Mountain rainbow trout—delicious, although my wife was astonished to see the fish's eyes staring back at her—fresh garden vegetables and homemade dessert. We savored every bite and every minute, realizing that someday the storied hotel would befall the same fate as Lem's old house.

Since the Appalachian Club buildings were vacated, there have been years of extensive studies, public hearing and heated debates. The sentiments of the public ranged from, "It's about time" to "It's sad to see them go." The park service suggested several plans. One alternative was to remove all man-made features, another plan suggested restoring all of the structures deemed worthy and yet another was to keep some of the buildings to restore and maintain for posterity.

Finally, a decision was made to keep seventeen of the cabins in Daisy Town, the Appalachian Clubhouse and the Spence Cabin located on Millionaire's Row. The plan for the cabins in Daisy Town was to use them for historic interpretation. The Appalachian Clubhouse and Spence Cabin (River Lodge) were to be restored and available for public day use, as a rental venue for special events.

Using stimulus monies from the U.S. government, the cabins were repaired enough to curb further deterioration, and a parking lot replaced a couple Daisy Town cabins that were demolished while the Appalachian Clubhouse and Spence Cabin were restored. In 2011, the clubhouse renovation was completed, and the Spence Cabin opened the following year.

Original residents and their families, as well as those whose families built getaway cabins, gathered Saturday, June 25, 2011, to visit the newly renovated Appalachian Clubhouse and reminisce about Elkmont. Winfred

Ownby attended and agreed to record his memories of his legendary great-uncle Lem Ownby.

The Pigeon Forge Department of Tourism hosts a weeklong event in January of each year called Wilderness Wildlife Week. Since the first Wilderness Wildlife event was held in January 1991, the event has grown from a half-day program and luncheon with sixty attendees to an entire week with several hundred presentations and thousands attending from all over the United States.

In 2008, I presented a program on Lem Ownby. The title of my program was "Uncle Lem Ownby: Sage of Elkmont." By this time, twenty-four years had passed since Lem Ownby died, so I wondered how much interest there would be in the last man to live in the Great Smoky Mountains National Park on a life-lease agreement. With several other interesting programs scheduled for the same hour, I figured fifty people would be a good turnout.

To my surprise and delight, the room was packed. A standing-room only crowd filled the space to more than the capacity of two hundred. Among those attending were relatives of Lem, acquaintances who remembered meeting him and curious individuals eager to learn about the mountain man. After the program, attendees lingered with questions and personal stories about Lem Ownby. Others inquired how to find more information.

During the program, I recited a poem that I wrote about Lem Ownby. Later, a local folk singer, Bob Brittle asked if he could use the poem as lyrics for a song. Known professionally as Whistlin' Bob, he set the words to music and sang it frequently during his performances.

At Wilderness Wildlife Week in 2009, I presented the program again to another full house. I was also asked to speak about Lem Ownby at other events, including one at Valley View Baptist Church, the church where Lem is buried. The interest exhibited at these events was the genesis for this book.

Perhaps Lem Ownby would be amused that the synchronized fireflies at Elkmont have become such a big attraction that the park service was forced to limit access during those weeks in early June when the insects are mating. In order to witness the phenomenon, visitors must board a bus at the Sugarlands Visitors Center to travel to see the spectacular show.

In 2010, Lee and Kevin Hill, great-great-nephews of Lem, established an outdoor and lifestyle store they named Uncle Lem's Mountain Outfitters. Located in Knoxville, the brothers wanted to capture the spirit of their kinsman.

A corner of the store is dedicated to Ownby, where there is a rocking chair and a mantle clock that came from his cabin. And like Uncle Lem, who

would attract campers and hikers to buy his honey, the brothers sell private-label honey created with Uncle Lem in mind.

When the store opened, Kevin Hill said, "We are trying to create an experience akin to the time, era and personality of Uncle Lem. We would like Uncle Lem to become a regional icon people feel connected to."

Seeing the Smokies today, it's hard to imagine all the damage and the scars that the massive logging operations left on the land, the streams and the wildlife. Thankfully, nature has finally reclaimed its land. The Great Smoky Mountains National Park receives more than nine million visitors annually, which is the highest visitation of any of the fifty-eight national parks.

Another lure, aside from the natural beauty of these ancient mountains, is the area's rich history. With interpretive centers scattered throughout the Great Smoky Mountains National Park, along with individual and shared efforts, the cultural aspect of the park will be perpetuated.

There is little doubt that Uncle Lem Ownby, the blind beekeeper who remained in his mountain home until he was the last man standing, forever will hold a place of honor in the annals of Smoky Mountain lore.

The porch of the Wonderland Hotel shortly before the historic hotel closed in 1992. *Author's private collection.*

Uncle Lem Ownby

Born high up in the Smokies,
'neath a stunning mountain peak.
Uncle Lem lived his ninety-four years
Along the rippling waters of Jake's Creek.

When Uncle Lem became a "growed" up man,
He asked Mimmie to be his wife.
She was a good and faithful partner,
For the remainder of her life.

Lem worked for the Lumber Comp'ny,
Back when he was young and strong.
He hauled logs down from the mountainside,
And loaded 'em on a train all day long.

He refused to leave his peaceful place,
For the creation of a park.
So, he made a deal with the government to stay,
He was happy as a lark.

Uncle Lem plowed the rugged mountainside,
And robbed honey from his bees.
He even planted a little orchard,
So he could grow some apple trees.

There were chickens around for breakfast eggs,
A hog for bacon, and plenty of milk and cream.
And he sometimes caught trout for dinner,
From the little icy mountain stream.

In his young days he kept a shotgun near,
Just in case he heard a bear.
If a predator came around ol, Lem's place,
It never stood a prayer.

When Mimmie passed away one day,
Uncle Lem was old and alone.
He had to make some adjustments,
After his devoted companion was gone.

He kept on working with his bees,
Long after he was blind.
To strangers who came by to say, "Hello,"
Uncle Lem was warm, friendly and kind

But one day some big shots from Washington town,
Came by to see old mountain man, Lem,
When he found out they were from Washington
He refused to see either of them.

In the evenings after the sun sank low,
Uncle Lem would sit by the old stove and rock,
While he listened to the constant ticking
Of his treasured old family clock.

Uncle Lem lived out a long, healthy life
With a remarkable unhurried grace.
He claimed eating mountain honey
Was the reason for his baby smooth face.

One of the last residents
To live in the National Park,
By the time he went to heaven
He'd left his immortal mark.

F. CARROLL McMAHAN
2008

BIBLIOGRAPHY

Arnett, Draper and Hagood. Attorneys at Law. Knoxville, TN. www.adh. com (accessed July 2013).

Arnett, Foster, Jr. "Citizens Voice: Uncle Lem Was Unimpressed by Justices," *Knoxville News-Sentinel*, 2010.

Brewer, Carson. *Great Smoky Mountains National Park*. Portland, OR: Graphic Arts Publishing Company, 1993.

————. *A Wonderment of Mountains: The Great Smokies*. Knoxville, TN: Tenpenny Publishing, 1981.

Bush, Florence Cope. *Dorie: Woman of the Mountains*. Knoxville: University of Tennessee Press, 1992.

Campbell, Carlos. *Birth of a National Park*. Asheville, NC: Inland Press, 1969.

Cave, Kent, supervisory ranger and Great Smoky Mountains National Park historian. Interview with author, 2013.

Cleveland, Todd M. "Cultural and Historic Landscape Assessment for the Elkmont Historic District, Great Smoky Mountains National Park." Report commissioned by park service. Sevier County, Tennessee. TRC Garrow and Associates, Inc. Atlanta, Georgia, 2004.

Dennis, Delmar. *The Great Smokies Yesterday and Today.* Sevierville, TN: Nandel Publishing Co., 1988.

Dumas, Jim. "Fabled Lem Ownby Finally Leaves Park." *(Pigeon Forge, TN) Star*, 1984.

Ellison, George. "Beekeeping in the Mountains." *Smoky Mountain News*, 2003.

Frome, Michael. *Strangers in High Places.* Knoxville: University of Tennessee Press, 1980.

Galyon, Judy. "Lem Ownby Will Not Vote." *(Pigeon Forge, TN) Star*, 1982.

Joslin, Preston J., PhD. *For Whom the Bell Tolls.* Sevierville, TN: self-published, 2005.

The Knoxville (TN) Journal. January 17, 1984.

Leabow, Wanda. E-mail message to author. July 30, 2013.

Lix, Courtney. "Mayna Avent: Artist in the Woods." *Smokies Life Magazine* 4, no. 2 (Spring 2009).

Long, Tony. "This Day in Tech Goes Analog: Halley's Comet Brushes Earth with Its Tail." 2009. www.wired.com/thisdayintech/2009/05/dayintech_0519.

Marriages of the Mountains 1856-1914 (Smoky Mountain Historical Society, Sevierville, Tennessee 1998).

McCoy, George. *Lem Ownby Will Not Vote.* Asheville, NC: Inland Press, 1976.

McMahan, Carroll. "Upland Chronicles: John O. Morrell Loved the Smokies," *Mountain Press* (2012).

———. "Upland Chronicles: Lee Higdon Has Close Connection to Park," *Mountain Press* (2011).

———. "Upland Chronicles: Lee Ownby Walked the Walk," *Mountain Press* (2011).

———. "Upland Chronicles: Pug Murphy Thrilled by Clarence Darrow Encounter," *Mountain Press* (2012).

———. "Upland Chronicles: Shelton's Photos Chronicle Events, Places in the Smokies," *Mountain Press* (2012).

Morrell, John O. *The Mirth of a Park*. Gatlinburg, TN: self-published, 1960.

Muskateve, Laura. *Remembering Elkmont*. N.p.: self-published, 2007.

Neil's Gallery. Gatlinburg, TN. www.neilsgallery.com (accessed July 2013).

The Official Records of Atchley Funeral Home. Vol. 1. Sevierville, TN: Smoky Mountain Historical Society, 2002.

The Official Records of Atchley Funeral Home. Vol. 2. Sevierville, TN: Smoky Mountain Historical Society, 2002.

Ownby, Evolena. "Memories of Big Greenbrier." *Smoky Mountain Historical Society Journal* 23, no. 2 (1997).

Ownby, Winfred, grand-nephew of Lem Ownby. Interviews with author. 2013.

Pierce, Daniel. *The Great Smokies: From Natural Habitat to National Park*. Knoxville: University of Tennessee Press, 2000.

Schmidt, Ronald G., and William S. Hooks. *Whistle Over the Mountain: Timber, Track & Trails in the Tennessee Smokies*. Yellow Springs, OH: Graphicom Press, 1994.

Sevier County (TN) News-Record. January 18, 1984.

Sevier County (TN) Observer. "We Just Pass This Way One Time." August 1, 1974.

Sevier County Heritage Book Committee and County Heritage, Inc., *Sevier County and Its Heritage*. Vol. 2. Waynesville, NC: County Heritage, Inc., 2011.

Sevier County Heritage Committee and Don Mills, Inc. *Sevier County and Its Heritage*. Vol. 1. Waynesville, NC: County Heritage, Inc., 1994.

Smoky Mountain Ancestral Quest. David Beckwith, Chicago. www.smokykin.com (accessed July 2013).

Smoky Mountain Historical Society. *Gentle Winds of Change, A History of Sevier County, Tennessee 1900–1930*. Sevierville, TN: Smoky Mountain Historical Society, 1986.

"Synchronized Fire Flies at Elkmont." Little Valley Mountain Resort. www.littlevalleymountainresort.com/great-smoky-mountains/elkmont/fireflies (accessed July 2013).

The (Nashville) Tennessean. January 19, 1984.

The Tri-County (Seymour, TN) News. December 8, 1967.

Trentham, Bonnie. *Best Yet Stories of the Early Life and Times of Smoky Mountain People*. Maryville, TN: self-published, 2002.

Weals, Vic. *The Last Train to Elkmont*. Knoxville, TN: Olden Press, 1993.

Williams, Bobbie Jo. *In the Beginning: A History of Sevier County Association of Baptist Church Beginnings*. Rogersville, TN: East Tennessee Printing Company, Inc., 1991.

Williams, Tennessee. *Tennessee Williams: Memoirs*. Sewanee, TN: special arrangement with University of the South, 1972.

Williams, Theresa, grand-niece of Lem Ownby. Interviews with author, 2013.

Williams, Theresa. "Upland Chronicles: Brazelton Owenby Suffered a Tragic Summer Death." *Mountain Press* (2011).

ABOUT THE AUTHOR

F. Carroll McMahan was born and raised in the shadows of the Great Smoky Mountains National Park. He is the special projects facilitator for the Sevierville, Tennessee Chamber of Commerce; serves as county historian of Sevier County; and writes the "Upland Chronicles," a series that celebrates the heritage and past of Sevier County, published weekly in the *Mountain Press*. He is the recipient of the 2012 Community History Award presented by the East Tennessee Historical Society and the Historic Preservation Recognition Award presented by the Society of the Daughters of the American Revolution, Spencer Clack Chapter.

Courtesy of Richard Atchley Jr.